ASTONISHING
FANTASY WORLDS

ASTONISHING
FANTASY WORLDS

THE ULTIMATE GUIDE TO DRAWING ADVENTURE FANTASY ART

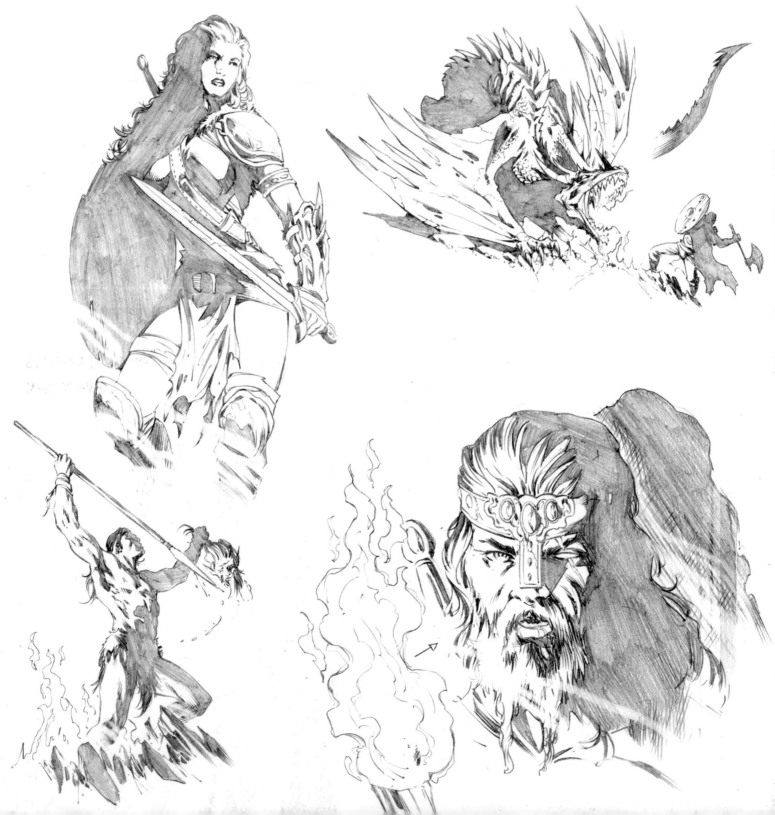

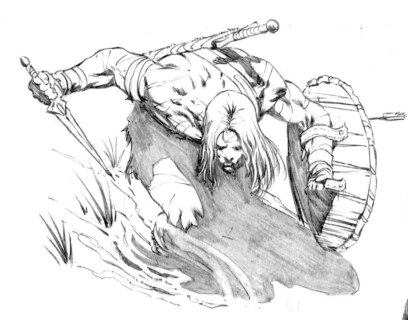

CHRISTOPHER HART

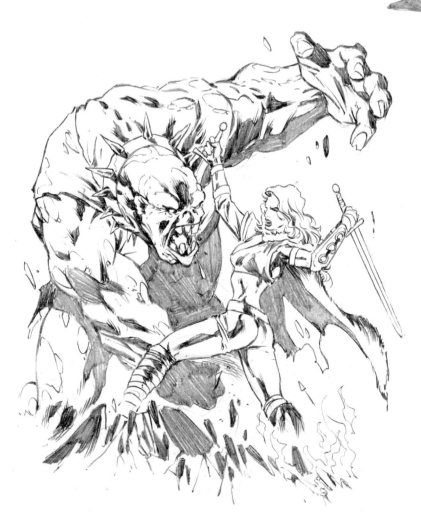

WATSON-GUPTILL PUBLICATIONS
NEW YORK

CONTRIBUTING ARTISTS

Darryl Banks
Cristina Francisco
Julius Gopez
Jonathan Lau
Ariel Padilla
Alves Wellinton

Executive Editor: Candace Raney
Senior Development Editor: Alisa Palazzo
Art Director: Timothy Hsu
Designer: Bob Fillie
Production: Salvatore Destro
Typeset in Gotham, Morpheus, and Knockout
Cover design by Timothy Hsu
Color by Mada Design, Inc.

First published in 2008
by Watson-Guptill Publications
Nielsen Business Media
a division of The Nielsen Company
770 Broadway
New York, NY 10003
www.watsonguptill.com

Library of Congress Cataloging-in-Publication Data
Hart, Christopher.
 Astonishing fantasy worlds : the ultimate guide to drawing
adventure fantasy art / Christopher Hart.
 p. cm.
 Includes index.
 ISBN-13: 978-0-8230-1472-9 (pbk.)
 ISBN-10: 0-8230-1472-X (pbk.)
 1. Fantasy in art. 2. Drawing—Technique. I. Title.
 NC825.F25H38 2008
 743'.87—dc22
 2008007659

Watson-Guptill Publications books are available at special discounts
when purchased in bulk for premiums and sales promotions, as well as
for fund-raising or educational use. Special editions or book excerpts
can be created to specification. For details, please contact the
Special Sales Director at the address above.

Printed in Malaysia

1 2 3 4 5 6 7 8 9 / 16 15 14 13 12 11 10 09 08

For Maria, Isabella, and Francesca

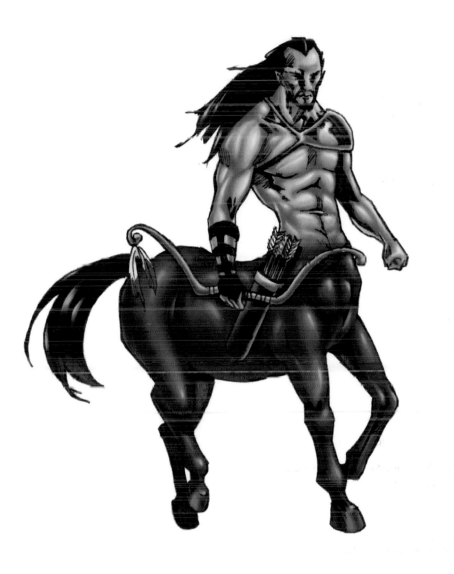

CONTENTS

INTRODUCTION

THIS IS A COMPLETE BOOK ON DRAWING fantasy art. In these richly illustrated, easy-to-follow tutorials, you will discover the amazing world of Vikings and primitive warlords, medieval knights, human-animal hybrid monsters, Gothic creatures of darkness, and nature's delightful faerie kingdom. You'll meet the most popular fantasy characters of all time, including dragons, wizards, ogres, trolls, barbarian men and women, serpent goddesses, vampires, wraiths, ghost pirates, and many, many more.

But this is more than just a book about drawing fantastic characters. You'll also learn to increase your artistic skills, because along with character-design instruction come specific lessons on body proportions, heroic anatomy, maximizing facial expressions and body attitudes, effective use of dramatic lighting, scene composition, and developing a story, to name just a few.

It is my intention to bring you as many step-by-step examples and visual hints as possible throughout this book. I believe that you cannot learn to draw simply by

reading about it. So, you'll want ample illustrations that allow you to clearly follow along, as well as illustrations that inspire. It's my goal to provide you with both.

Ever since I was a kid, from my earliest memories, I had a love affair with fantasy art. It captivated me. The fantasy genre held my imagination like nothing else. In it I saw endless horizons, stirrings of strange moral complexities between alien societies at war, adventures of immense proportions. At first, it was a genre on the periphery. But it has grown by leaps and bounds into the dominant pop movement that it is today, overshadowing all other entertainment genres in the media of comics, movies, and television. I hope you enjoy our journey into the realm of the fantastic, a voyage into a world of astonishing imagination.

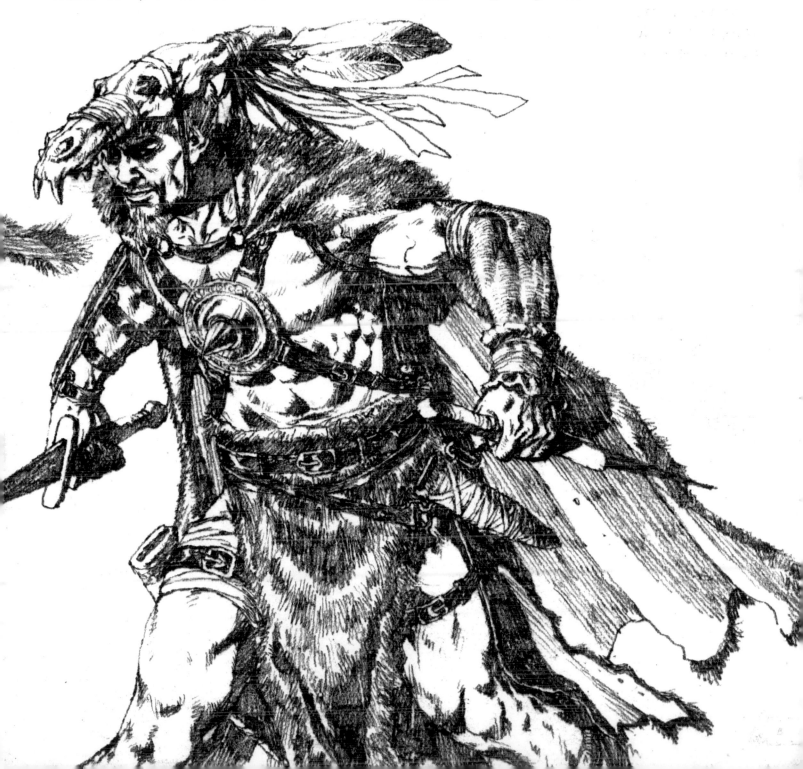

The Barbarians

THE MEN AND WOMEN OF THE BARBARIAN AGE lived in a wicked world. They carried primitive weapons, wore animal skins, and illuminated the night with torches. They fought off invaders to keep what was theirs. These were tough characters. They owned the earth. Some say they were more savage than human, but that misses the point. In a world with beasts of unimaginable fury and tribes of assassins roaming the land, men and women did what they had to in order to survive. And they did so by sword, by brute strength, and even by dark magic.

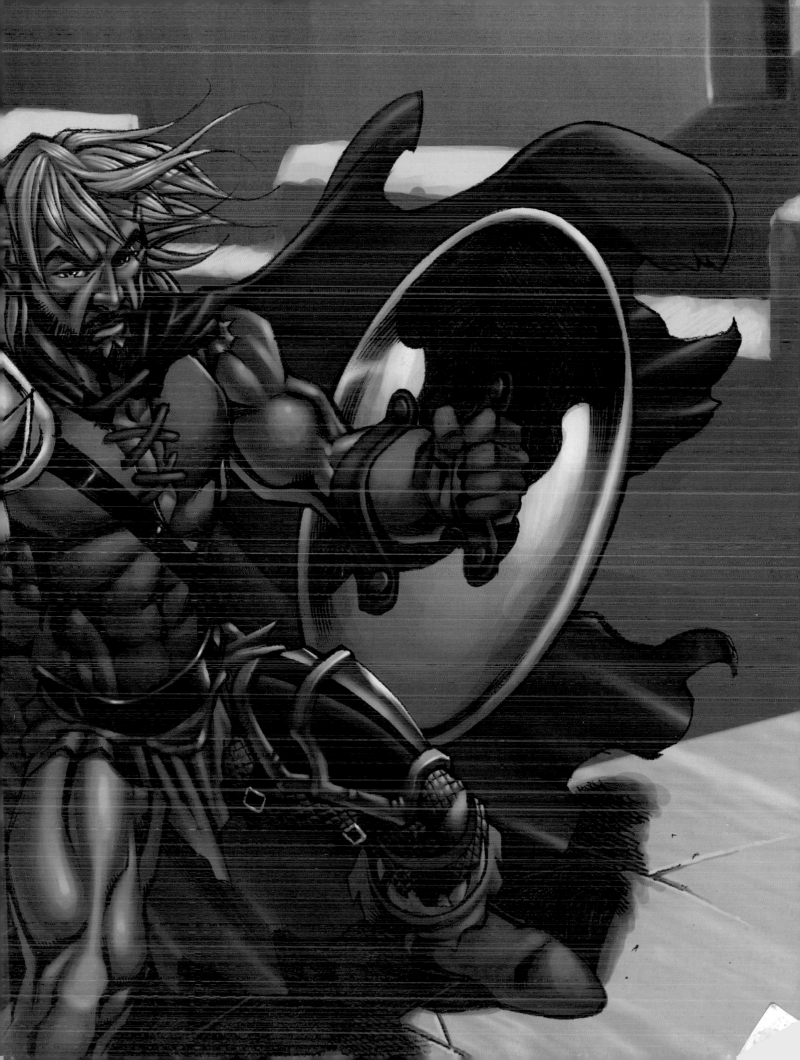

BASIC BARBARIAN

The barbarians are superpowerful fighters, gladiators of a different world. The women are highly attractive warriors in their own right, provocative yet also extremely capable and athletically shaped. And then there are the most dangerous barbarians of them all: the charismatic warlords, tall and menacing figures who lead armies of followers in their cults of death and destruction. The male barbarian's toughness first shows itself in the head construction. This is evidenced in the extrawide cheekbones, heavy brow, and angular jaw.

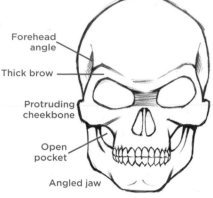

Forehead angle
Thick brow
Protruding cheekbone
Open pocket
Angled jaw
Square chin

FRONT VIEW

By examining the warrior's skull, which shows some adjustments not seen on a normal skull, you learn why the barbarian head has some of the contours it does. For example, the open pockets on the sides correspond to the sunken areas in the cheeks. Comparing the skull to the finished drawing helps in understanding that each specific contour line on the surface of the face actually relates to something—a specific bump or dip—on the skull underneath.

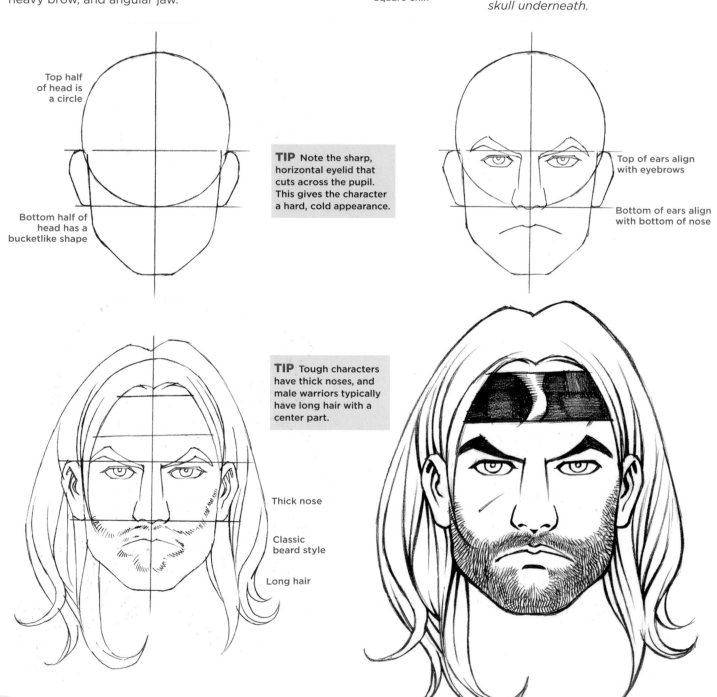

Top half of head is a circle

Bottom half of head has a bucketlike shape

TIP Note the sharp, horizontal eyelid that cuts across the pupil. This gives the character a hard, cold appearance.

Top of ears align with eyebrows

Bottom of ears align with bottom of nose

TIP Tough characters have thick noses, and male warriors typically have long hair with a center part.

Thick nose

Classic beard style

Long hair

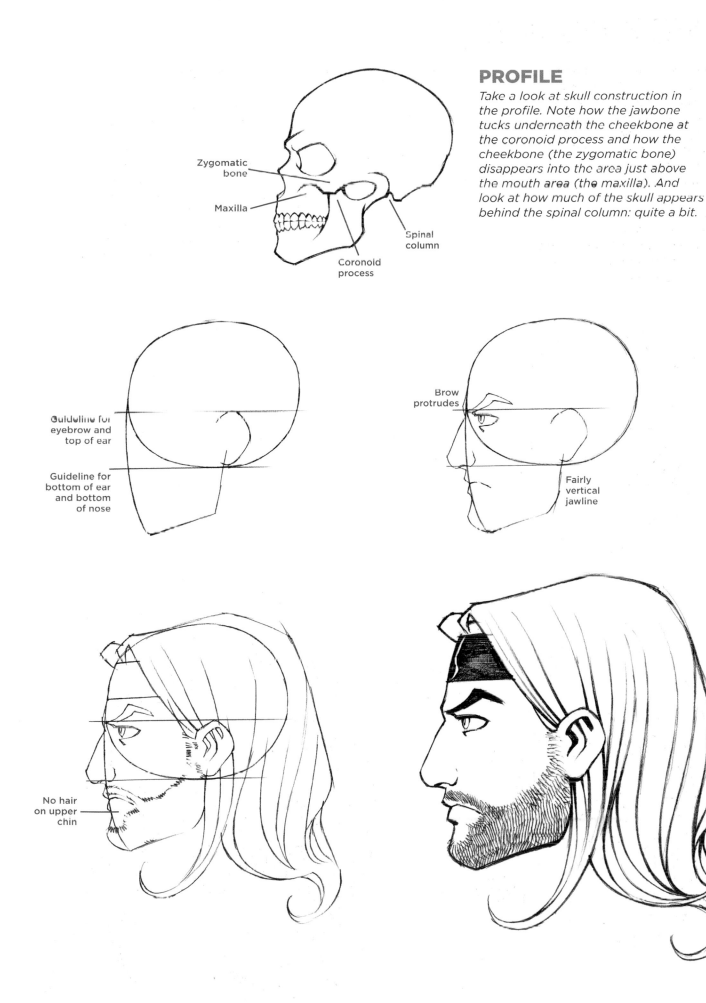

PROFILE

Take a look at skull construction in the profile. Note how the jawbone tucks underneath the cheekbone at the coronoid process and how the cheekbone (the zygomatic bone) disappears into the area just above the mouth area (the maxilla). And look at how much of the skull appears behind the spinal column: quite a bit.

Zygomatic bone

Maxilla

Coronoid process

Spinal column

Guideline for eyebrow and top of ear

Guideline for bottom of ear and bottom of nose

Brow protrudes

Fairly vertical jawline

No hair on upper chin

FEMALE WARRIOR

As you can see from the skull and related illustrations, women's cheekbones are higher and more slender than men's.

No heavy brows on females (it's only a male thing)

Wide cheekbones

Narrow jaw

FRONT VIEW

Although the female barbarian's skull is narrower than that of the male, the cheekbones are still wide and prominent. But note how the heavy brow has been completely eliminated.

Sharp jaw angle

TIP Since she's a warrior, the basic outline of her head does display sharp angles around the jawline; it's not the soft, round face of your typical iPod-carrying coed.

TIP The headdress is important; it's often metallic, to make her look of a certain rank—and also for self-defense, like armor.

Oversized— never small— primitive jewelry

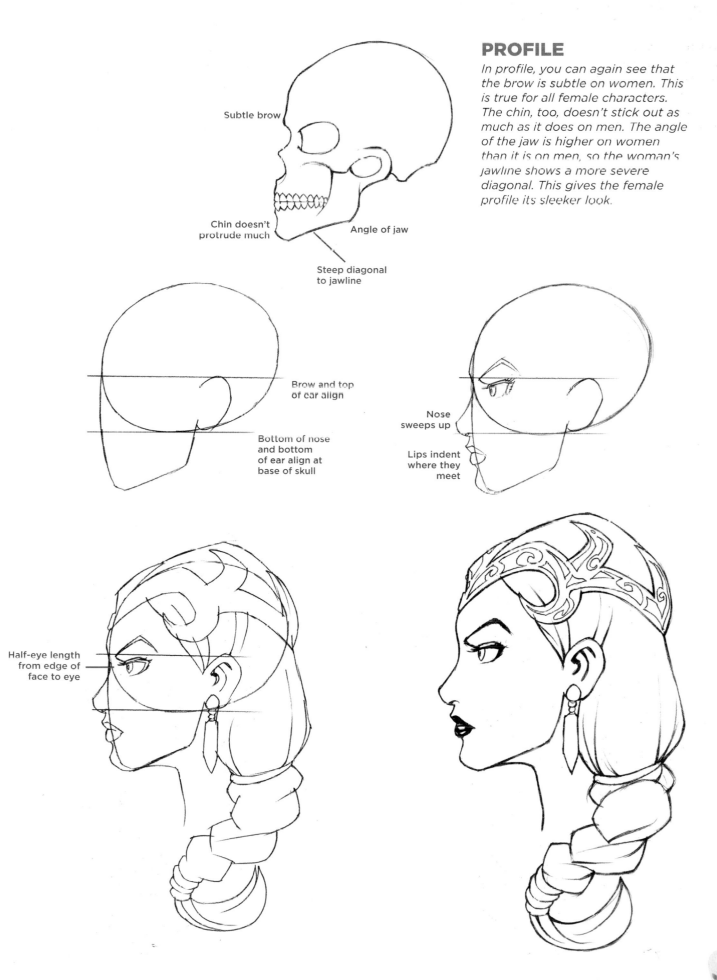

PROFILE

In profile, you can again see that the brow is subtle on women. This is true for all female characters. The chin, too, doesn't stick out as much as it does on men. The angle of the jaw is higher on women than it is on men, so the woman's jawline shows a more severe diagonal. This gives the female profile its sleeker look.

Subtle brow

Chin doesn't protrude much

Angle of jaw

Steep diagonal to jawline

Brow and top of ear align

Bottom of nose and bottom of ear align at base of skull

Nose sweeps up

Lips indent where they meet

Half-eye length from edge of face to eye

PROPORTIONS FOR WARRIOR BODIES

Artists measure body proportions by "stacking heads"—i.e., using the character's own head as the fixed measurement to determine overall body height. A real person is about 6½ heads tall. The difference in height between real men and women, for drawing's sake, isn't great: under half a head. However, because warrior men are massive, the women simply look too giant if they're not significantly shorter. Therefore, they generally work best at a full head shorter than their male counterparts. These characters show the male warrior at 9 heads and the female at 8 heads—heroic proportions.

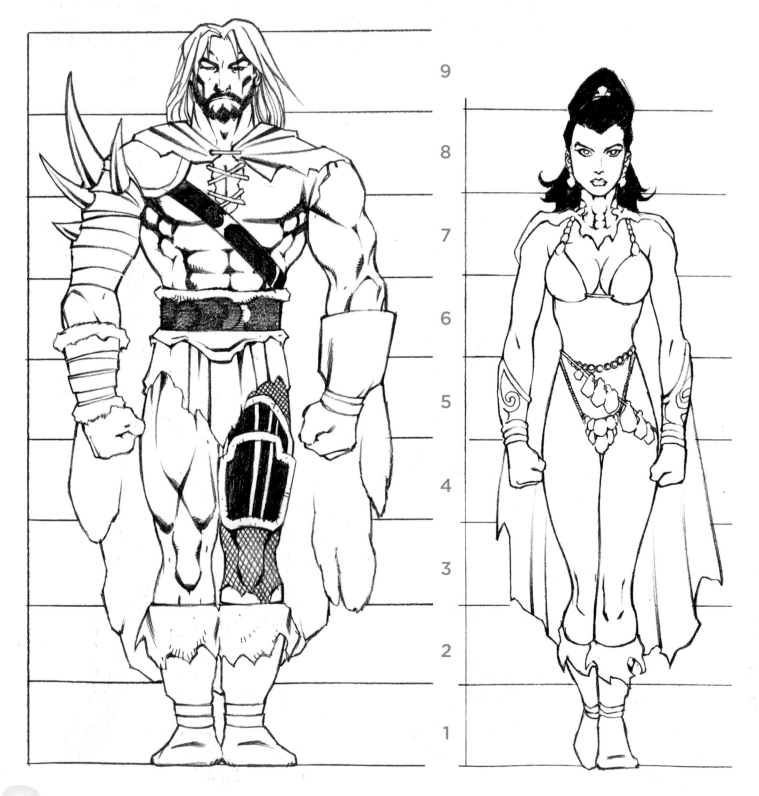

BASIC WARRIOR HERO AND HEROINE

These are the guys who save the world—well, maybe not *our* world but a really cool world somewhere, lost in time. It is an unkind and unforgiving place, where a battle won is only a short pause in a protracted war with the forces of darkness. There is no time for glory or celebration. There are no uniforms. These are nomadic warriors, pursuing their enemies throughout the land and even to the Gates of Hell.

When designing a cast of characters in your fantasy settings, one of your initial decisions should be—and this may seem odd at first, but you'll see that it's not—the temperature in this primitive environment. Ask yourself this not because you want to know whether your character should wear a hat like your mom always bugged you to do every time you left the house, but because fantasy worlds exist on the edge. Everything is of an extreme nature. It's either brutally hot or icy cold. If it's freezing, the characters will be wearing massive animal skins to stay warm. If it's searing hot, they will wear few garments and be attired like the characters you see here. But you must keep it consistent. You can't have two guys in the same scene, fighting, one wearing layers of animal skins and the other in a loincloth. They've gotta both be listening to the same weather report!

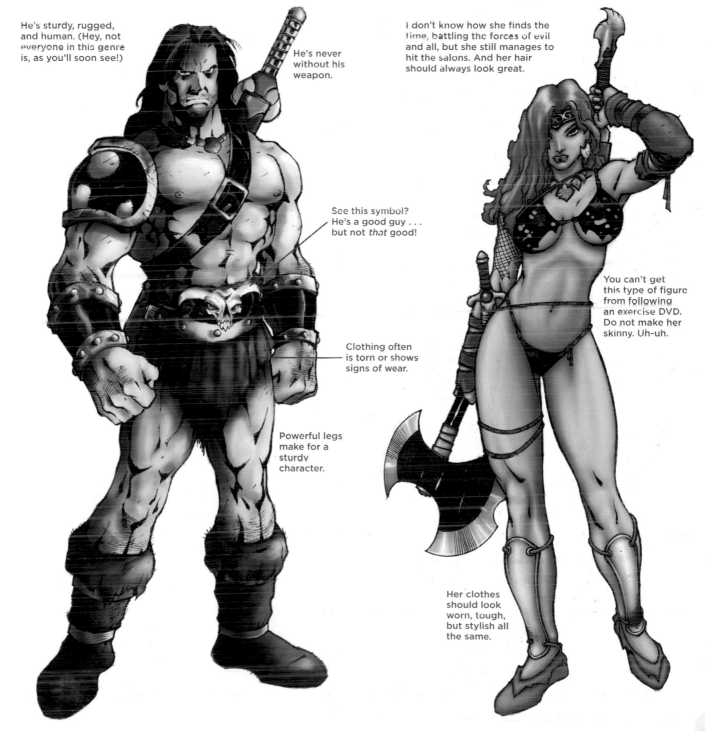

He's sturdy, rugged, and human. (Hey, not everyone in this genre is, as you'll soon see!)

He's never without his weapon.

See this symbol? He's a good guy . . . but not *that* good!

Clothing often is torn or shows signs of wear.

Powerful legs make for a sturdy character.

I don't know how she finds the time, battling the forces of evil and all, but she still manages to hit the salons. And her hair should always look great.

You can't get this type of figure from following an exercise DVD. Do not make her skinny. Uh-uh.

Her clothes should look worn, tough, but stylish all the same.

17

BASIC SUPPORTING CHARACTERS

EVIL WARLORD

He gives the orders to a vast army of ruthless assassins, a cult of death and darkness. There are some specific visual flags that set him apart from the warrior-hero class—and I'm not talking solely about his expression. These are classic motifs used throughout the fantasy kingdom for creating popular warlord character types.

GIANT

Lumbering, slow, but powerful and thoroughly mean, the giant is often used as a solitary character featured in some of the most exciting fight scenes. He is frequently a "surprise" character. By that I mean he is suddenly introduced to the reader at a perilous moment, to great effect. For example, as the hero warrior climbs a craggy mountain, hits a ledge, and pulls himself up to safety for a much-needed breather, he finds himself—to his *surprise*—to have intruded on the dwelling of the giant, who is none too happy to have visitors.

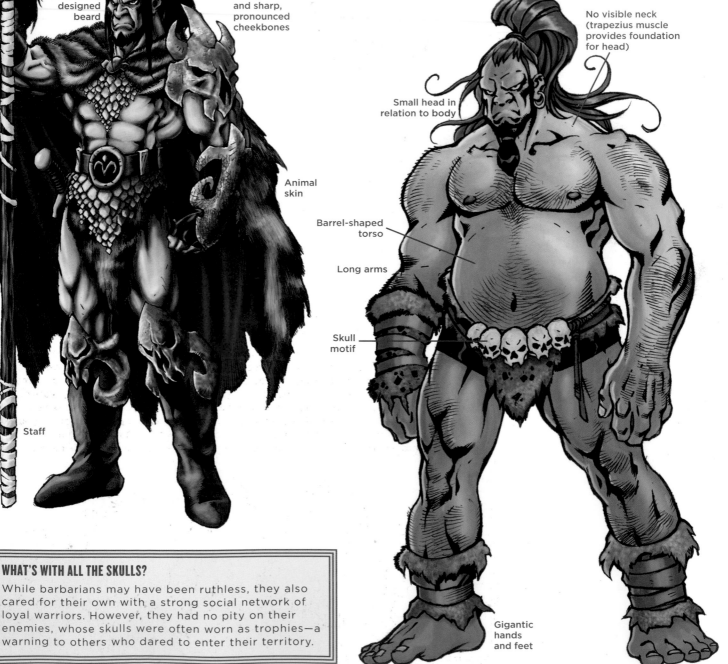

More structured, designed beard

Raised, manly ponytail

Heavy brow and sharp, pronounced cheekbones

Animal skin

Staff

No visible neck (trapezius muscle provides foundation for head)

Small head in relation to body

Barrel-shaped torso

Long arms

Skull motif

Gigantic hands and feet

WHAT'S WITH ALL THE SKULLS?

While barbarians may have been ruthless, they also cared for their own with a strong social network of loyal warriors. However, they had no pity on their enemies, whose skulls were often worn as trophies—a warning to others who dared to enter their territory.

FANTASY BEAST

Wild, feral, insane. This is a great character, because it's the ultimate antagonist. When killed, it vanishes into thin air, as if returning to the source of the bewitched spell from whence it came. It can also turn to stone, crumble, and blow away with the wind, like grains of sand. You see, you can end the scene with even more drama than delivering the death blow. This is what is so impressive about the fantasy genre. It allows you to get poetic, even in the midst of violence, and elevate the moment to an allegorical status. Maybe the warrior was never fighting anything at all but himself. Perhaps the beast was all an illusion.

SIZE COMPARISONS OF POPULAR BARBARIAN CHARACTERS

In a land of warriors and barbarians, you create impact not just from varying the height of characters, but also from increasing the size of their girth—often to twice that of a normal man. This makes the characters—especially bad guys and beasts—amazingly impressive.

 A note about beasts: Although mythical and invented creatures can be any size you want, real animals, like lions and tigers, are actually shorter than people. Therefore, if you are creating a strange and powerful creature based on an existing animal—be it a wolf, tiger, or leopard—increasing its width may be more effective than increasing its height.

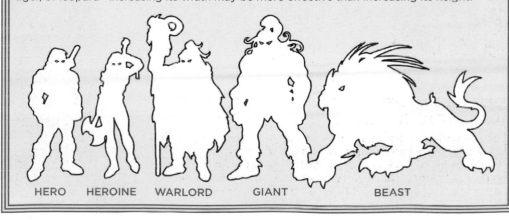

HERO HEROINE WARLORD GIANT BEAST

ACTION POSING STEP BY STEP

In the harsh environment of the barbarian world, it's easy to create an action pose. Just turn up the power of the wind machines so that they blow the hair and the cape until they're flapping. Then bend the character's knees, have him hold up his weapons, and voilà! Now that looks like an action pose!

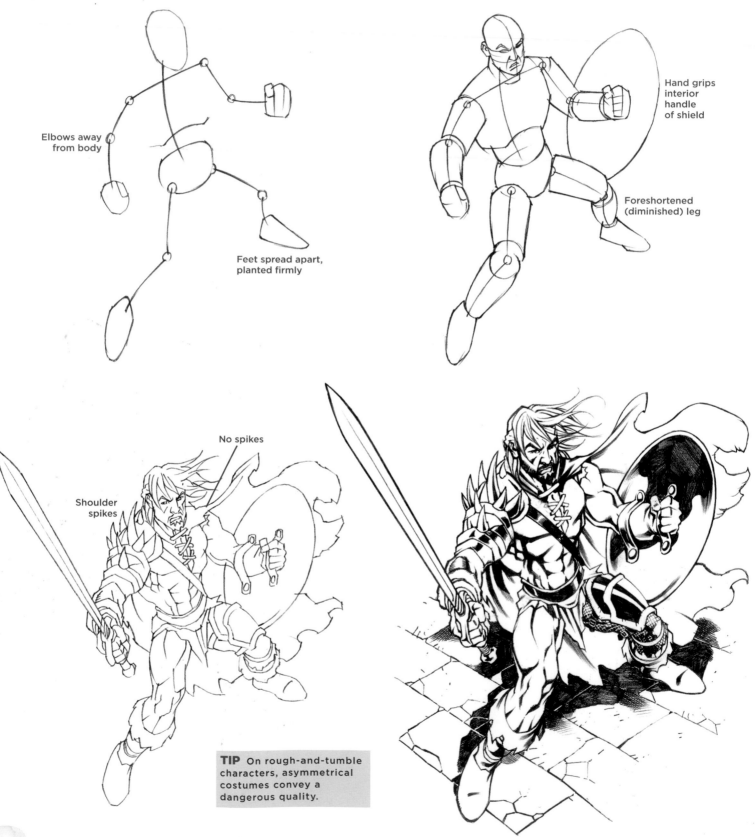

Elbows away from body

Feet spread apart, planted firmly

Hand grips interior handle of shield

Foreshortened (diminished) leg

No spikes

Shoulder spikes

TIP On rough-and-tumble characters, asymmetrical costumes convey a dangerous quality.

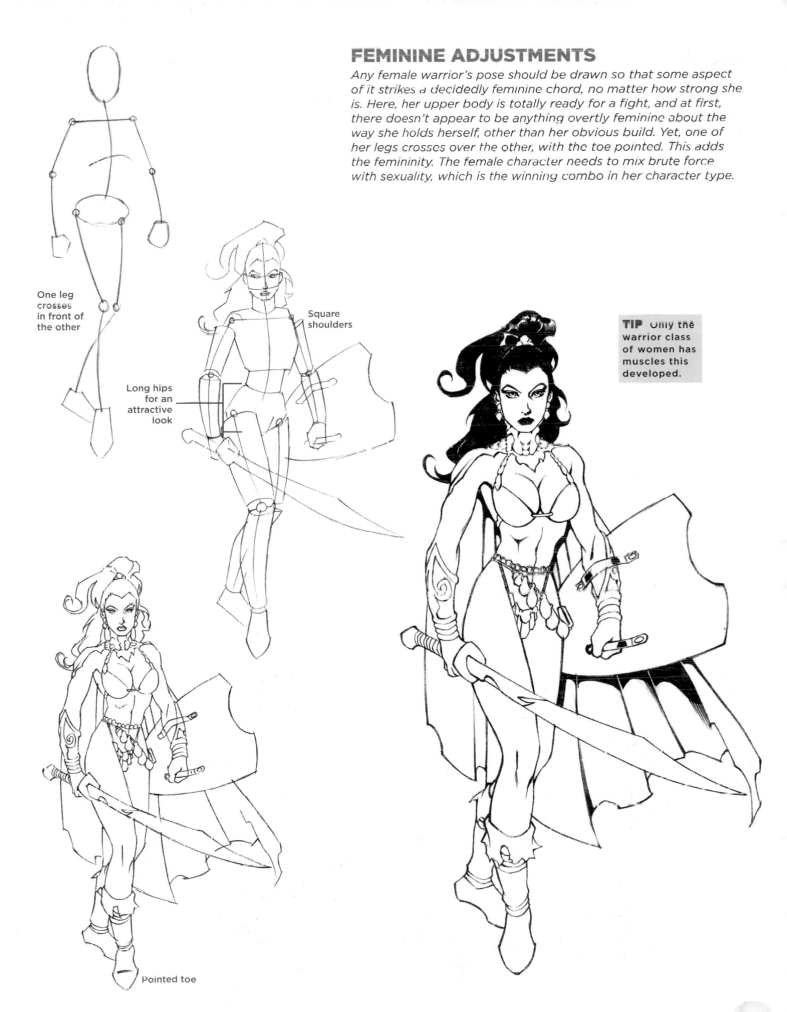

FEMININE ADJUSTMENTS

Any female warrior's pose should be drawn so that some aspect of it strikes a decidedly feminine chord, no matter how strong she is. Here, her upper body is totally ready for a fight, and at first, there doesn't appear to be anything overtly feminine about the way she holds herself, other than her obvious build. Yet, one of her legs crosses over the other, with the toe pointed. This adds the femininity. The female character needs to mix brute force with sexuality, which is the winning combo in her character type.

One leg crosses in front of the other

Square shoulders

Long hips for an attractive look

TIP Only the warrior class of women has muscles this developed.

Pointed toe

BARBARIAN WOMEN

Female barbarians are wild and savage. Their natural beauty does nothing to diminish their animalistic instinct to kill all invaders. And *invaders* means anyone who wanders into their territory, no matter how innocently.

And in case you can't tell, there's a tad of hostility toward men. In fact, the female barbarian enjoys the opportunity to challenge all legendary male fighters.

Legs in "crossover" position

ANIMAL-CLAN BARBARIAN

Different barbarians belong to different clans. This one belongs to the clan of the wolf, as evidenced by the skin she wears. She takes on the personality of the creature, living in the woods like a wild animal. Other popular animal clans are the large cats of Africa and large birds of prey.

JUNGLE BARBARIAN

Like a panther, she uses stealth to attack her prey. Her pose takes on the nature of a four-legged animal timing its opportunities. Enter the jungle—her domain—and you won't see her until it's too late. She travels from tree to tree or moves through the tall brush, unseen. She is often nocturnal. This character type often belongs to a clan that carries on ritualistic rites and human sacrifices, for which these characters may wear body paint and headdresses.

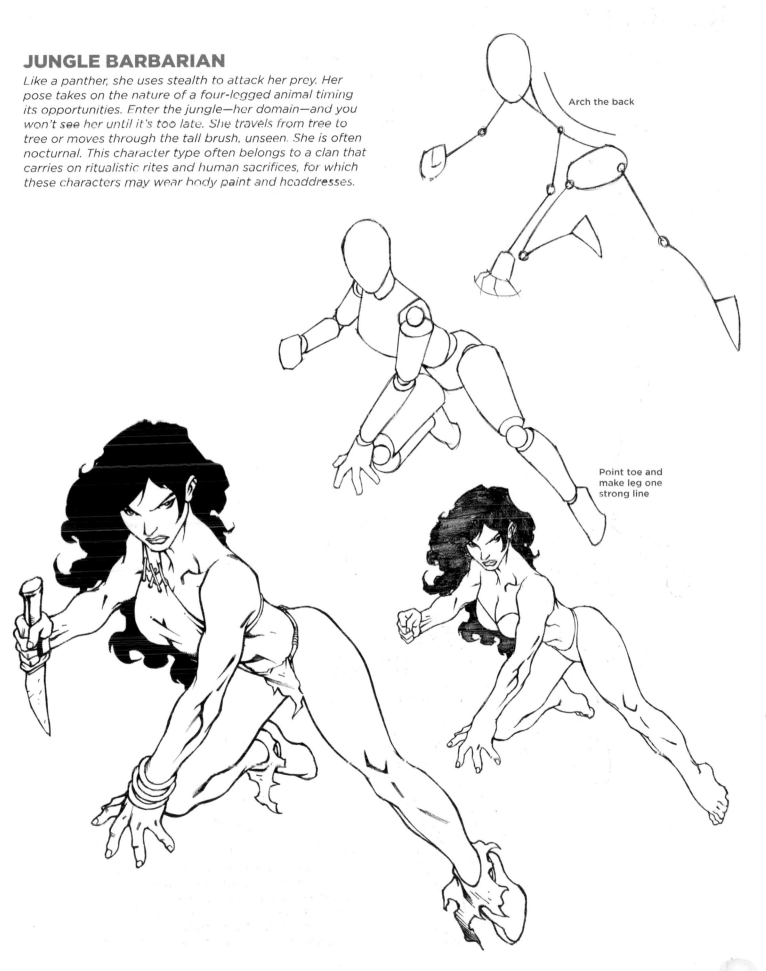

Arch the back

Point toe and make leg one strong line

EXTREME POWER!

There are action poses, and then there is extreme, barbarian-style power! The two are not the same. When drawing scenes in which power has to be extreme, a special technique is called for. Everything moves in one direction. There's no counterbalancing force that moves in the opposite direction. Let's see how this works on a few examples.

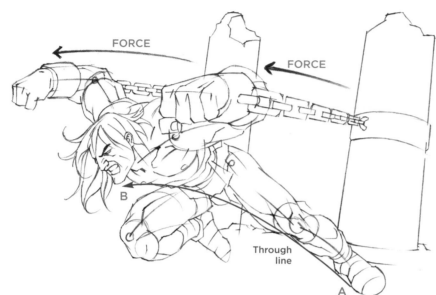

FORCE

FORCE

B

Through line

A

DRIVING FORWARD

The character drives forward with such thrust that he becomes almost horizontal. Arms, torso, and legs take on the same directionality as the chains. In fact, his arms are held over his head and body. Notice the long "through line" that travels from his grounded foot (A) all the way to his chin (B). You can draw a smooth, arched line from one point to the other.

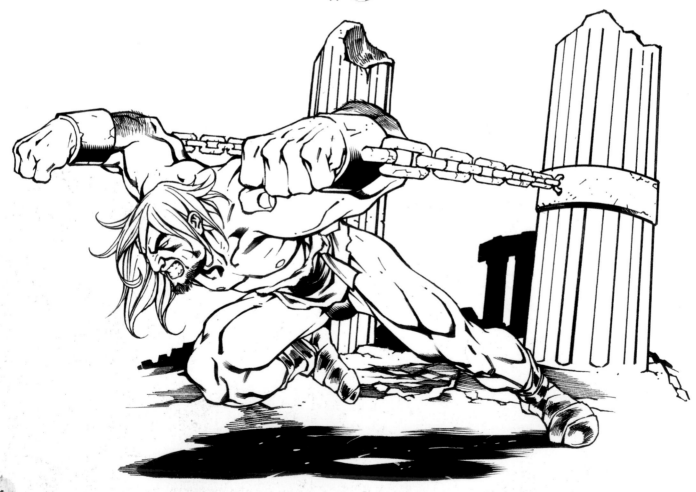

PULLING

The trainer pushes off the front foot to create distance between him and Mr. Fangs. He also leans so far back that his extended leg is almost parallel to the ground. The hands are spaced well apart to grip with more strength.

FORCE

HERE, KITTY, KITTY. . . .

HEAVY LIFTING

This is not what my wife means when she asks me to go out and bring in the grocery bags. Not that I couldn't lift this tree if I really wanted to.

Did you ever hear people say, "When you lift something, bend your knees!" I always find those people annoying. Anyway, it's also true for power scenes (and you don't have to send your characters to the chiropractor after you've drawn them). When the knees are bent, the power center of the character—the hips—is set lower to the ground, and the legs can then be spread wider apart. All this translates, visually, into a stronger stance, which the audience picks up on instinctively. If he stood straight-legged, the tree would appear light and easy to lift. That might mean that your character is superstrong, but it won't look dramatic. In drama, a character must struggle. *That's why they call it* drama.

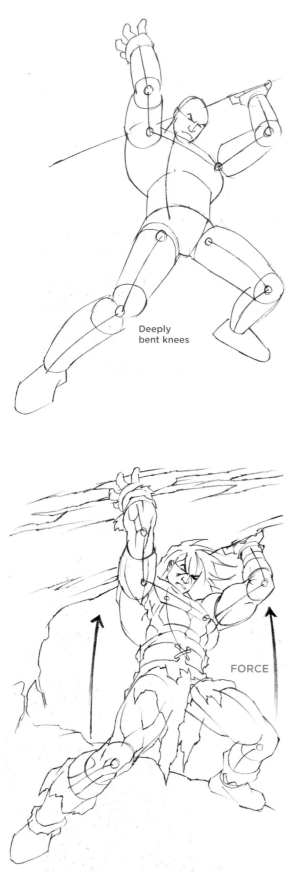

Deeply bent knees

FORCE

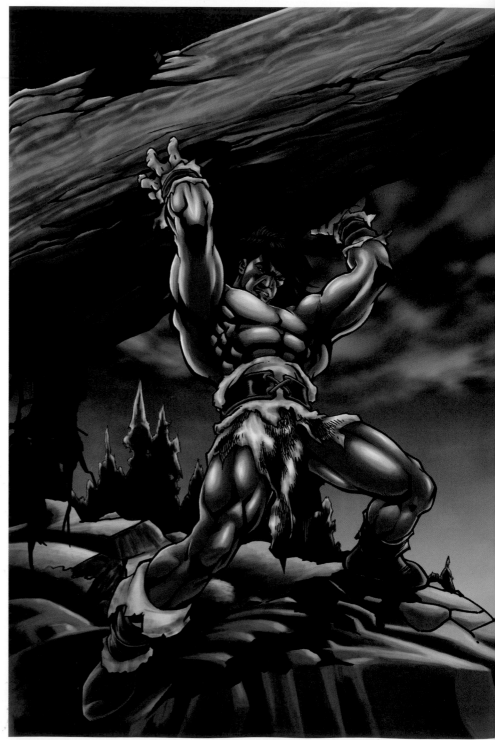

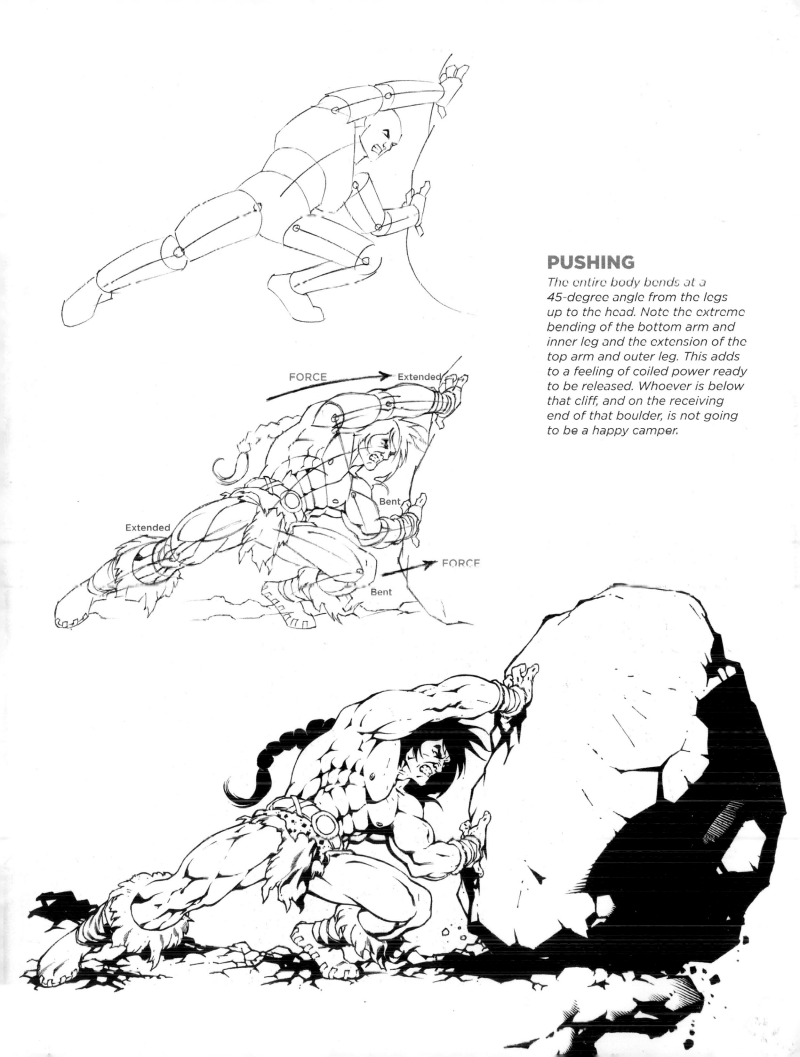

PUSHING

The entire body bends at a 45-degree angle from the legs up to the head. Note the extreme bending of the bottom arm and inner leg and the extension of the top arm and outer leg. This adds to a feeling of coiled power ready to be released. Whoever is below that cliff, and on the receiving end of that boulder, is not going to be a happy camper.

FORCE → Extended

Extended

Bent

FORCE →

Bent

CREATURES

As readers traverse the fantasy kingdoms, they will undoubtedly be visited by a few unwelcome creatures. These will appear, at a distance, to be large, powerful humans. However, on closer inspection, it is discovered they're not human at all but strange beings: part animal, part beast. These are among the most feared foes anyone can encounter in the realm of darkness.

Creativity and invention are key in creating these nightmarish villains. Yours can be as original as you wish. However, these types have become so popular throughout fantasy illustration that they've established themselves as standards and, therefore, are worth adding to your skill set. Barbarian creatures are like humans but with much smaller foreheads and bigger, bonier brows. Their jaws are simply massive. Their bodies are larger, thicker, and just more impressive all around. They can also have such features as "empty" eyes, bottom fangs, warlike hairstyles, and primitive clothing.

BASIC CREATURE HEAD CONSTRUCTION

Note the tiny cranium, which conveys a sluggish thinker. The long face is for creatures with an overabundance of sharp teeth. The massive lower jaw is a sign of primitive strength. And note the eye patch.

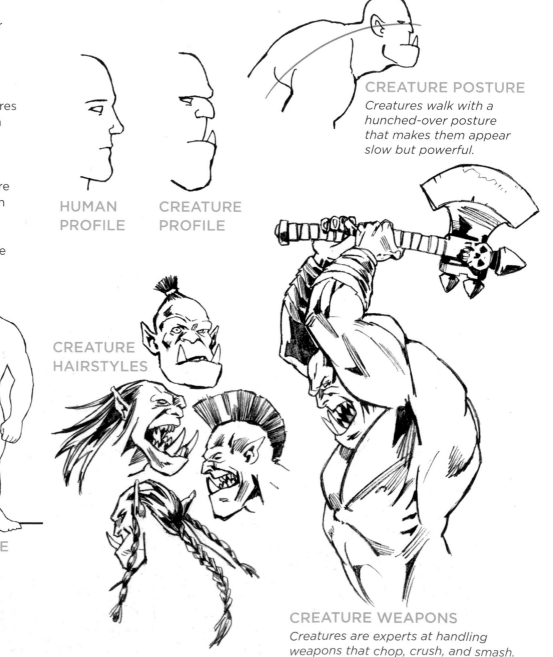

CREATURE POSTURE

Creatures walk with a hunched-over posture that makes them appear slow but powerful.

HUMAN PROFILE

CREATURE PROFILE

CREATURE HAIRSTYLES

CREATURE WEAPONS

Creatures are experts at handling weapons that chop, crush, and smash.

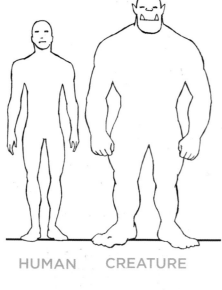

HUMAN CREATURE

FIERCE COSTUMES

Historically, warriors in primitive societies have displayed their ferocity by dressing in warlike costumes. The sight of such a battle-clad warrior sent chills of fear down an enemy's spine. We borrow this conceit and use it to enhance the appearance of our creature characters.

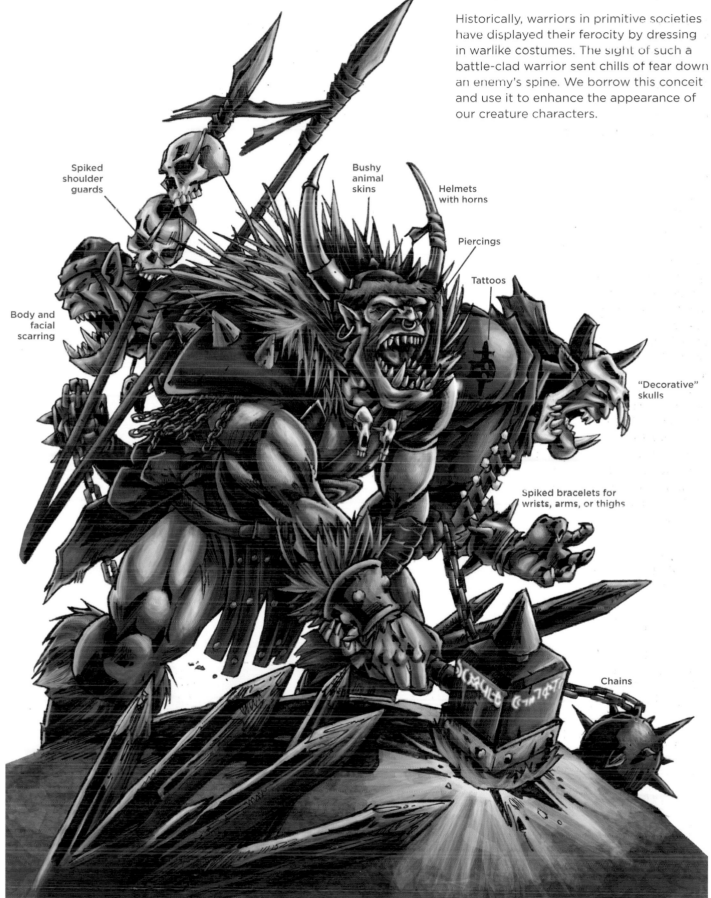

Spiked shoulder guards

Bushy animal skins

Helmets with horns

Piercings

Tattoos

Body and facial scarring

"Decorative" skulls

Spiked bracelets for wrists, arms, or thighs

Chains

THE BARBARIAN WORLD

Barbarians are often portrayed as serially nomadic, setting up temporary villages and moving on. They create huts, stables, funeral pyres, and pits for roasting game, as well as primitive kiosks for merchants selling their wares. There should be a feeling of commotion and commerce, of smoke and fire, and of messengers arriving and leaving on horseback.

Note that the wide shot of the village would turn into a mass of visual sprawl were it not framed by the structures to either side of the panel, which serve to "bookend" the scene.

Barbarian society is one of the few fantasy genres in which the warriors come in all ages and fight throughout their lifetime (similar to how it was for many knights in the Middle Ages). No one got Social Security.

The general populace wears skins, furs, necklaces, and bracelets for the wrists, upper arms, and thighs.

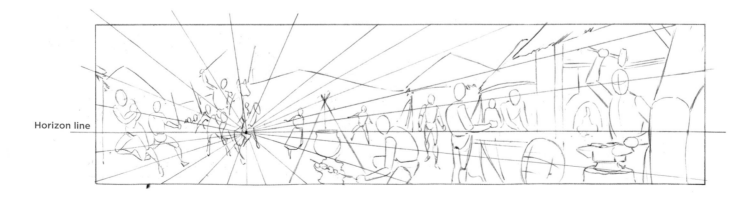

Horizon line

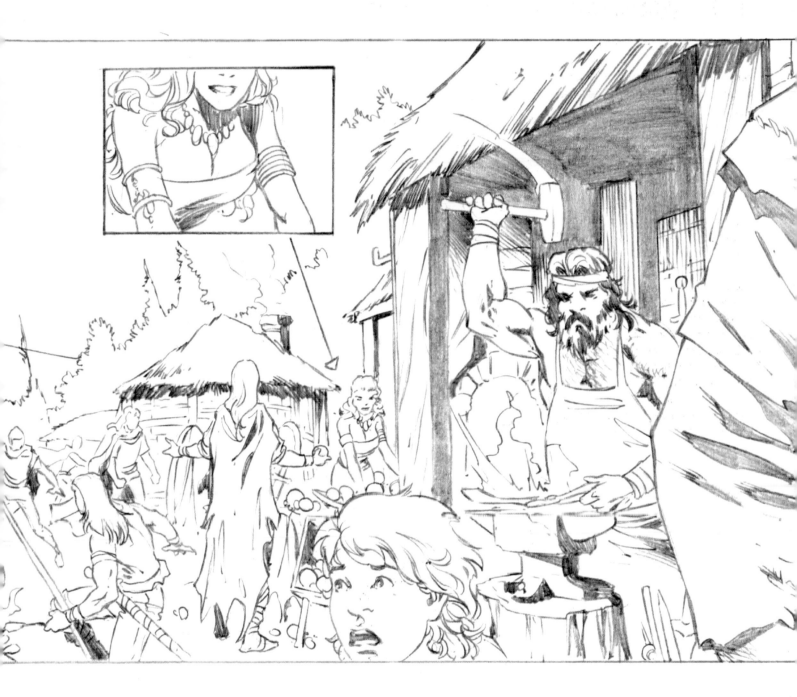

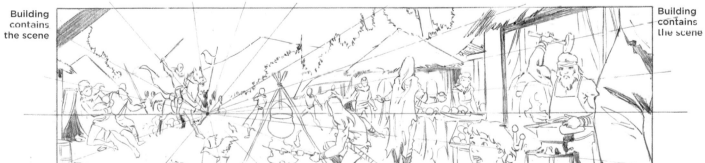

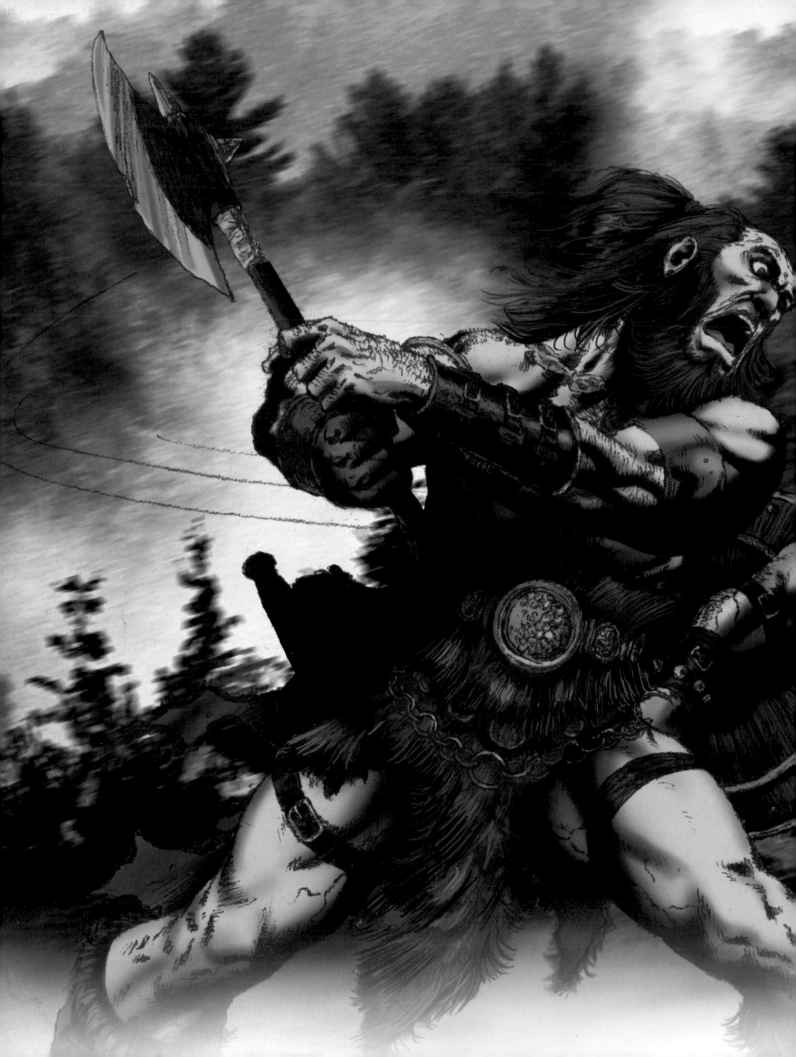

ENTERING THE WORLD OF FANTASY ILLUSTRATION AND ART IS
like going on an adventure to uncharted lands. Some of the
inhabitants look very different, even exotic and strange.
We're on such a journey, you and I. And we'll be
disembarking at many ports along the way.
The next stop is the land of

THE·VIKINGS

VIKING INVADERS

The Vikings existed at the same time as knights and were at their most powerful between AD 800 and 1000. They invaded Europe relentlessly during that time, often returning to the places they plundered over and over again. You could bribe a Viking army commander into leaving your village alone, but then he would pocket the money and burn your town to the ground anyway. True fact.

The most recognizable feature of the Viking is the striking pair of horns on the metal helmet. In cartoons, the horns are drawn small. In fantasy illustration, they can be long and dramatic. Repeat the horns elsewhere on the costume as a motif—for example, on the shoulder guards. Some artists also repeat the horns on forearm and knee guards.

Unlike knights (see page 56), there was nothing chivalrous or dashing about these tough Viking warriors. Note the one-handed axe instead of the long sword for close-up, intense fighting and for destroying castle doors. The clothes were bulky and heavy. Remember, they traveled long distances in the Nordic open-sea air. And that was before Gore-Tex!

Stocky body

Short legs

Circular shield

Edges of cape fold over

Thick limbs

Animal-skin cape with ruffled exterior, smooth interior

Uneven strap placement

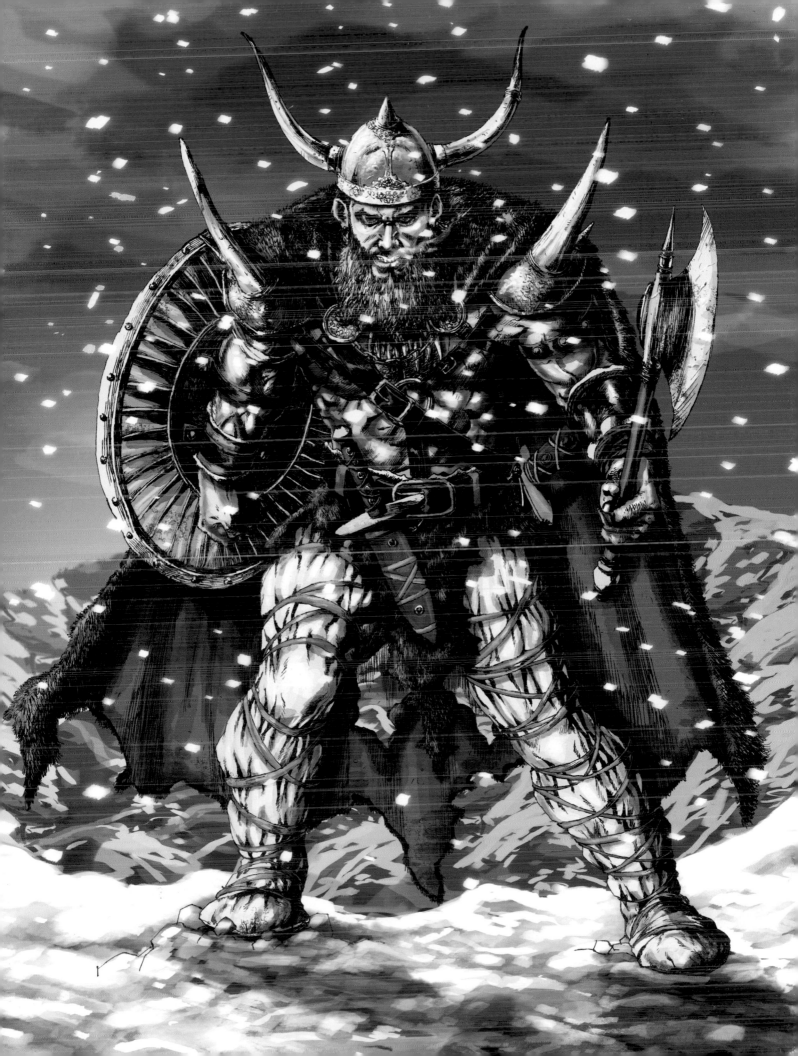

DWARF FIGHTER

A powerful class of Viking warrior is the dwarf knight. Although I personally resist using small people as characters in art because I don't believe in exploiting physical difficulties, the dwarf knight is a robust, proud, and adept fighter. He is, therefore, a respected member of the fantasy crew, well established in the fantasy genre, and held in high esteem. In fact, the entire fantasy genre is filled with people as well as fantasy beings of all different shapes and sizes—and no one is of higher or lower rank due to size. It is the ultimate egalitarian society.

The dwarf fighter has a stocky build, with short, muscular arms and legs. He shows little or no neck, and his head appears to be wedged tightly onto broad shoulders. A wild beard surrounds his face. The long cape increases the appearance of his stature. The axe is a good fighting weapon, but it is also effective for an assault on a fortress. An army of these axe-wielding fighters will splinter a bulwark into bits of timber in no time.

Wild beard and hair

Stocky trunk with short area between rib cage and hips

Chin tucks into shoulder

Arm swings across body, showing follow-through of motion

Feet wide apart for a strong stance

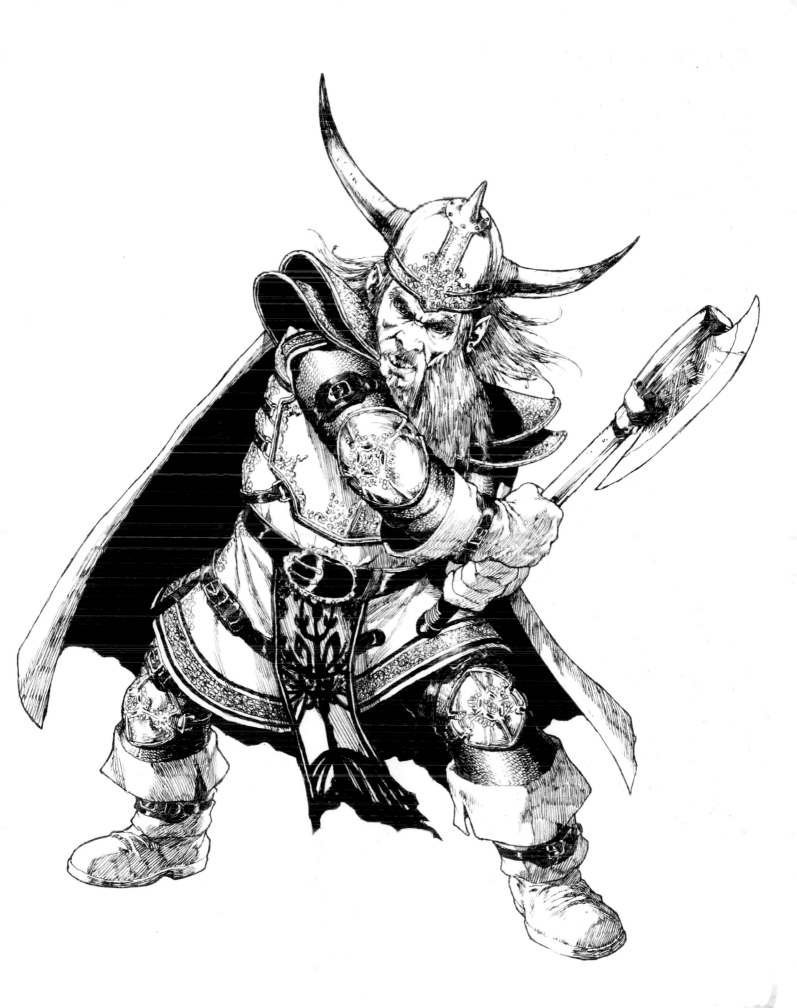

VIKING BARBARIANS

These treacherous marauders bring darkness upon the land and fear into the hearts of innocent villagers. Historically, there is much truth to their legend of savagery. But they are still admired for their incredible physical fortitude. They commandeered the unforgiving seas on small open crafts with nothing more than oars and muscle.

Primitive weapons

Huge, articulated muscles

Wide, thick torso

Heavy garments of skins and fur

CURSED SEMIHUMANS

Trolls, giants, and Cyclopes are but a small sampling of the strange creatures one is apt to find in this genre. They should be oddly misshapen: too tall, too short, too fat, or too gangly. Here, the hands and feet are oversized while the head is undersized, a classic look for a giant. The small head makes the giant look even taller and more massive.

Gigantic hands

Leather wristbands for a medieval look

Small head, tiny ear

Tree-trunk legs

Huge feet

SWORDFIGHTS

In a violent community such as that of the Vikings, there are going to be swordfights. To illustrate these conflicts convincingly, make use of three things: shields, follow-through, and variety.

THE SHIELD

Don't forget that the shield is also an offensive weapon! It can be used to strike anywhere on the body. Or, bop your enemy on the head with it.

FOLLOW-THROUGH

The long sword (any sword with a handle long enough to be held with two hands) is a heavy piece of metal. When such a weapon is swung, the momentum really carries it, and it can't be stopped suddenly. So, the follow-through—the continuation of the action through to its natural completion—has to continue around the entire body and beyond.

Follow-through continues past body

USING DIFFERENT WEAPONS

It's not always sword versus sword. Some of the most dramatic fights occur between foes using different weapons, which heightens the differences between the fighting tribes. And you can never have too many weapons. You never know when a dagger, for example, may come in handy (right). You can pull it out and point it at your enemy's throat before he has a chance to remove his sword from his scabbard. Axes and crossbows might also come in handy. It's only logical.

VIKING WOMEN

Viking women are warriors, too. Their minimalist dress consists of armor plates, leather straps, and animal skins.

ANATOMY FOR FANTASY WARRIORS

Whether they're men or women, barbarian and Viking warriors are all physically superior fighters, and their musculature and anatomy bears this out. All the major muscle groups flex when these fantasy characters fight, and you need to have a passing familiarity with where the definition lines should go in order to draw them. The muscles take very specific paths, and they wind and interlace through the body. The simplified muscle charts on the next few pages provide a quick reference.

FRONT

The upper leg muscles are long, while the muscles of the calves bunch up. Conversely, the muscles of the upper arms bunch, while the forearm muscles are long.

A. Rectus femoris
B. Vastus medialis
C. Vastus lateralis
D. Gastrocnemius
E. Peroneus longus
F. Adductor longus
G. Brachioradialis
H. Flexor carpi radialis
I. Biceps
J. Deltoids
K. Trapezius
L. Pectoralis major
M. Triceps
N. Brachialis
O. Biceps
P. Flexor carpi ulnaris
Q. Palmaris longus
R. Brachioradialis
S. Extensor carpi radialis brevis
T. Bone
U. Obliquus externus
V. Rectus abdominis
W. Sternocleidomastoideus
X. Latissimus dorsi

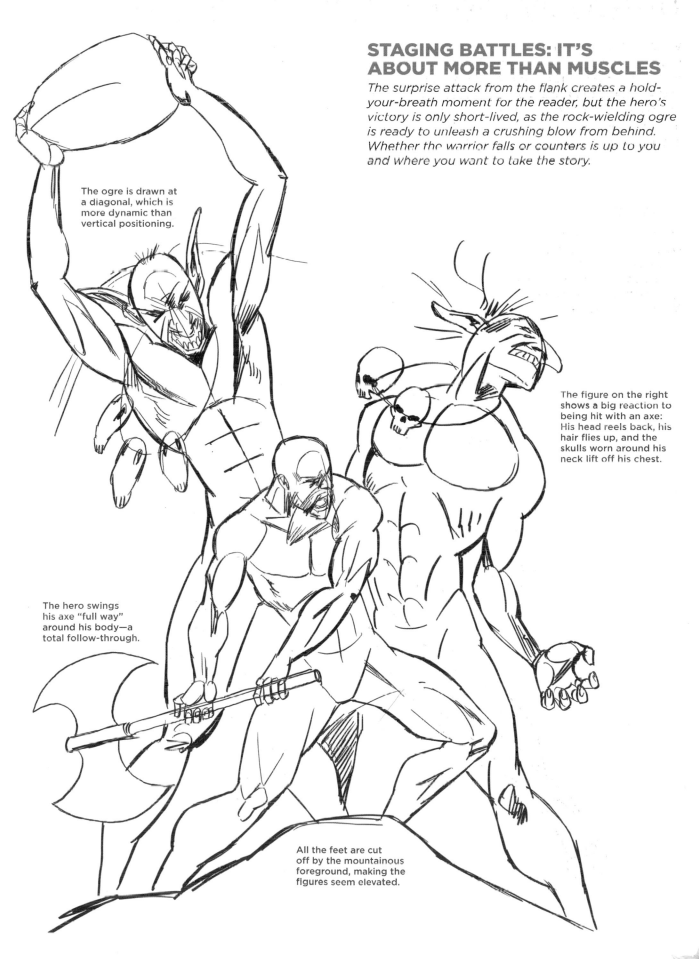

STAGING BATTLES: IT'S ABOUT MORE THAN MUSCLES

The surprise attack from the flank creates a hold-your-breath moment for the reader, but the hero's victory is only short-lived, as the rock-wielding ogre is ready to unleash a crushing blow from behind. Whether the warrior falls or counters is up to you and where you want to take the story.

The ogre is drawn at a diagonal, which is more dynamic than vertical positioning.

The figure on the right shows a big reaction to being hit with an axe: His head reels back, his hair flies up, and the skulls worn around his neck lift off his chest.

The hero swings his axe "full way" around his body—a total follow-through.

All the feet are cut off by the mountainous foreground, making the figures seem elevated.

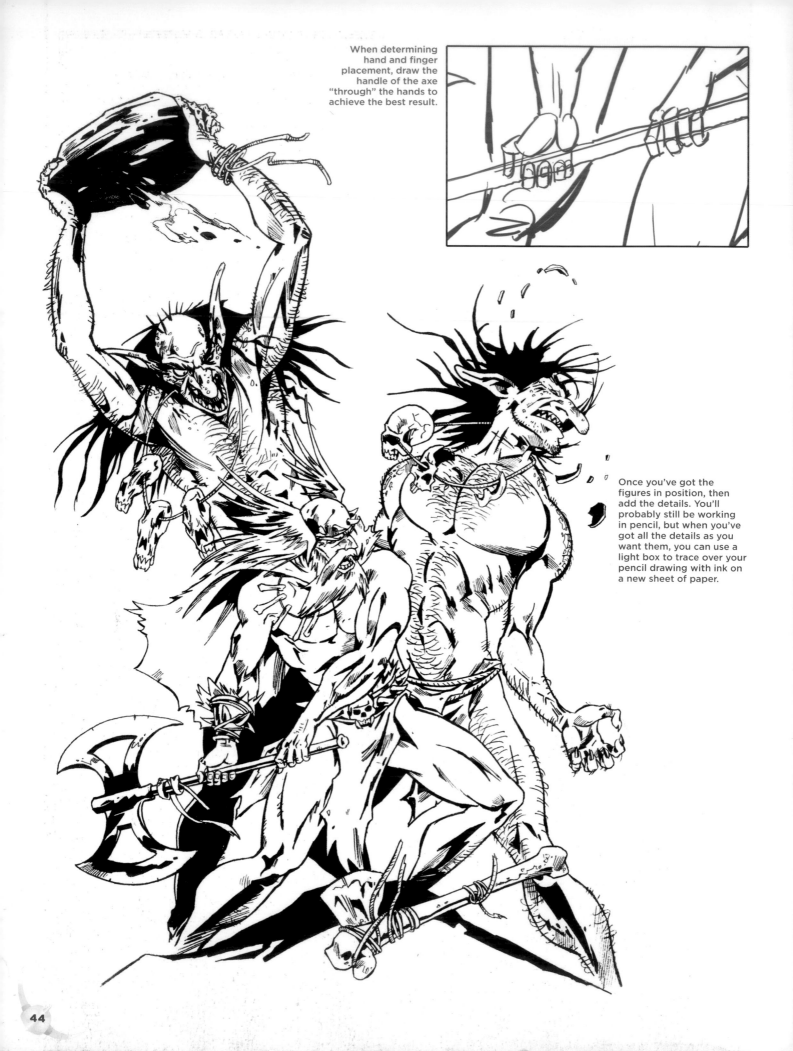

When determining hand and finger placement, draw the handle of the axe "through" the hands to achieve the best result.

Once you've got the figures in position, then add the details. You'll probably still be working in pencil, but when you've got all the details as you want them, you can use a light box to trace over your pencil drawing with ink on a new sheet of paper.

REINVENTING HISTORY

Visual artists take great license with history. Take Vikings, for example. The vast evidence is that Vikings were without ethics decimating much of Europe for centuries. They were ruthless and cruel Nordic pirates with disgusting ways to torture and kill.

And yet, their beautiful horned helmets, rugged animal skins, classic beards, and indomitable physiques conflated to give them a heroic visual presence. So, fantasy artists took the toughness of Vikings and combined it with their masculine look to create *heroes*—nothing like the true Vikings, who were exclusively bad guys. But hey, they don't call it *fantasy* for nothing!

BACK

The back flexes and articulates the muscles most when it is arching or when the shoulder blades are pushing together.

A. Deltoid
B. Trapezius
C. Trapezius
D. Latissimus dorsi
E. Obliquus externus
F. Gluteus maximus
G. Vastus lateralis
H. Semitendinosus
I. Gastrocnemius
J. Gastrocnemius
K. Achilles tendon
L. Biceps
M. Triceps
N. Brachialis
O. Brachioradialis
P. Triceps (outer head)
Q. Triceps (inner head)
R. Brachioradialis

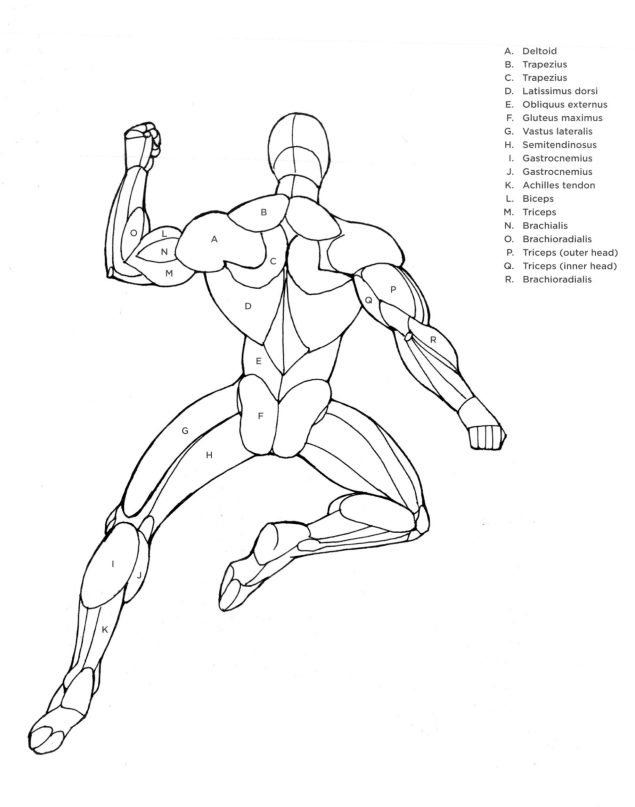

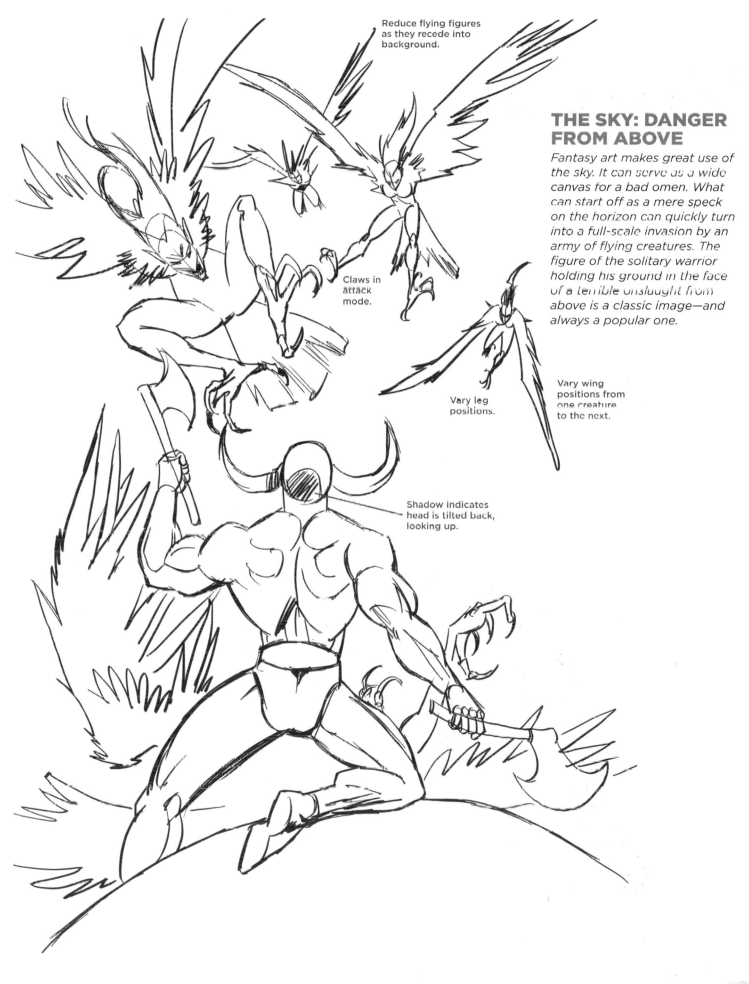

Reduce flying figures as they recede into background.

THE SKY: DANGER FROM ABOVE

Fantasy art makes great use of the sky. It can serve as a wide canvas for a bad omen. What can start off as a mere speck on the horizon can quickly turn into a full-scale invasion by an army of flying creatures. The figure of the solitary warrior holding his ground in the face of a terrible onslaught from above is a classic image—and always a popular one.

Claws in attack mode.

Vary leg positions.

Vary wing positions from one creature to the next.

Shadow indicates head is tilted back, looking up.

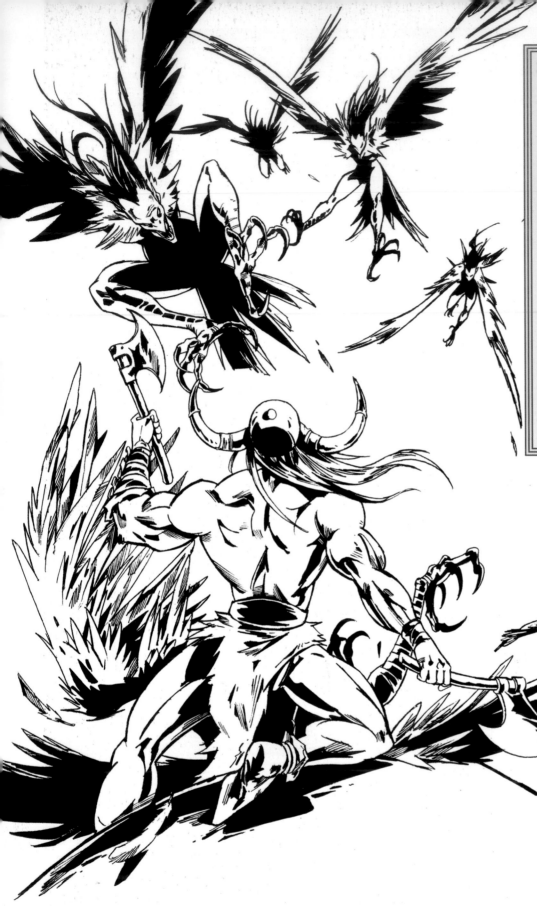

SUGGESTING A STORY

A picture is more interesting if you can give the reader a reason to linger and "discover" more about it. So, what's going on in this picture? The first thing is obvious: He's getting attacked. And he's vastly outnumbered, so he'll most likely be killed. And that's the whole story, right? But wait. A closer look shows that another story element has also been planted: A dead, winged creature lies in front of him. It seems that he has already tangled with one of them and not only survived but killed it—and remained unscathed. Well, perhaps he's not so outmatched after all! This could be a more interesting battle than it appeared at first glance. And that's what we mean by *suggesting a story*.

Planting a story element makes readers look twice at a picture and draws them in. This scene suddenly becomes more than a pretty image— it has a past and a possible future. And that's the essence of good fantasy art.

DETAIL: LEFT HAND
N. Brachialis

DETAIL: RIGHT HAND
O. Brachioradialis

APPLYING TONE

Consider applying color or tone to suit the emotional mood of the scene rather than to literally represent the background images. For example, this sky has been darkened to represent the emotional moment: an imminent battle to the death.

SIDE (FEMALE)

The female fantasy warrior is sexy, but she has definitely done her share of pull-ups in the gym. Still, her figure is drawn with longer muscles, rather than with the short, bunching muscles typical of male heroes. One word of advice: If you're a giant, don't whistle at babes with spears. It really ticks them off.

A. Biceps
B. Coracobrachialis
C. Triceps
D. Sternocleidomastoideus
E. Collarbone
F. Sternum (breastbone)
G. Rib cage
H. Obliquus externus
I. Rectus abdominis
J. Obliquus externus
K. Rectus femoris
L. Vastus lateralis
M. Peroneus longus
N. Adductor longus
O. Vastus medialis
P. Rectus femoris

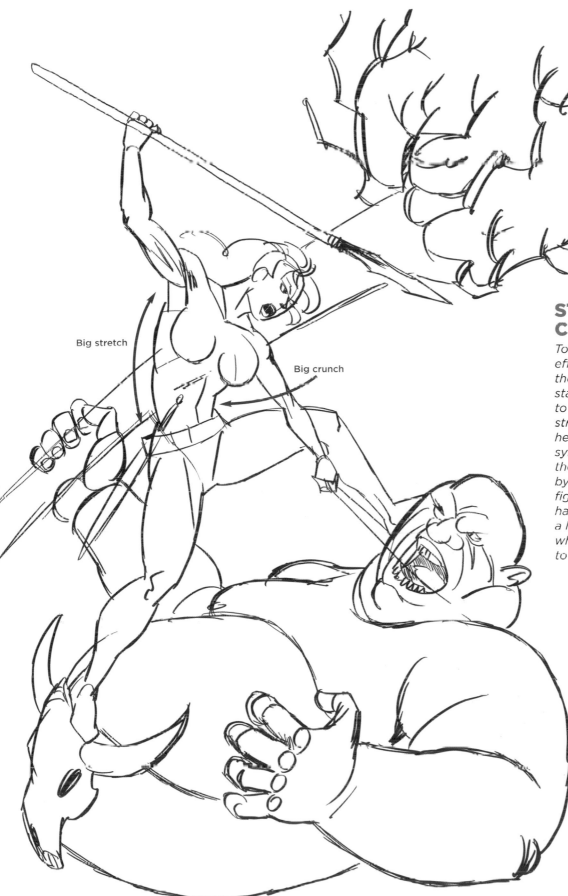

Big stretch

Big crunch

STRETCH AND CRUNCH

To give this pose maximum effect, you've got to show the female figure in a heroic stance. The body must appear to be yearning, struggling, striving, reaching—it won't look heroic if it looks balanced, symmetrical, and calm. One of the ways to achieve this look is by stretching one side of the figure while crunching down hard on the other side. It adds a lot of stress to the body, which is exactly what you want to show in a scene such as this.

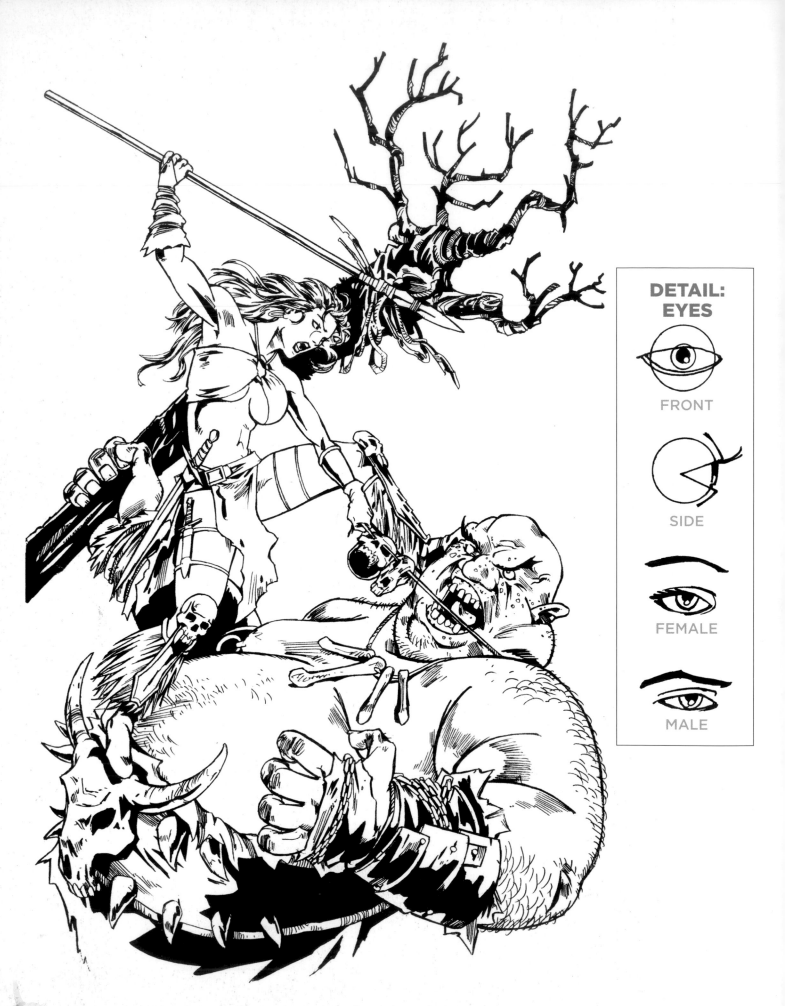

DETAIL:
EYES

FRONT

SIDE

FEMALE

MALE

THE CLASSIC PRE-ATTACK POSE

There are certain moments that make a scene, and then there are in-between moments that are best avoided. An in-between moment would be her jabbing her spear tentatively at the giant, trying to keep him at bay. The most dramatic moments are big. Big windups, big attacks, big follow-throughs.

Note the creative way in which she is approaching this battle: She climbs up on the giant's huge belly and actually gains a height advantage over him.

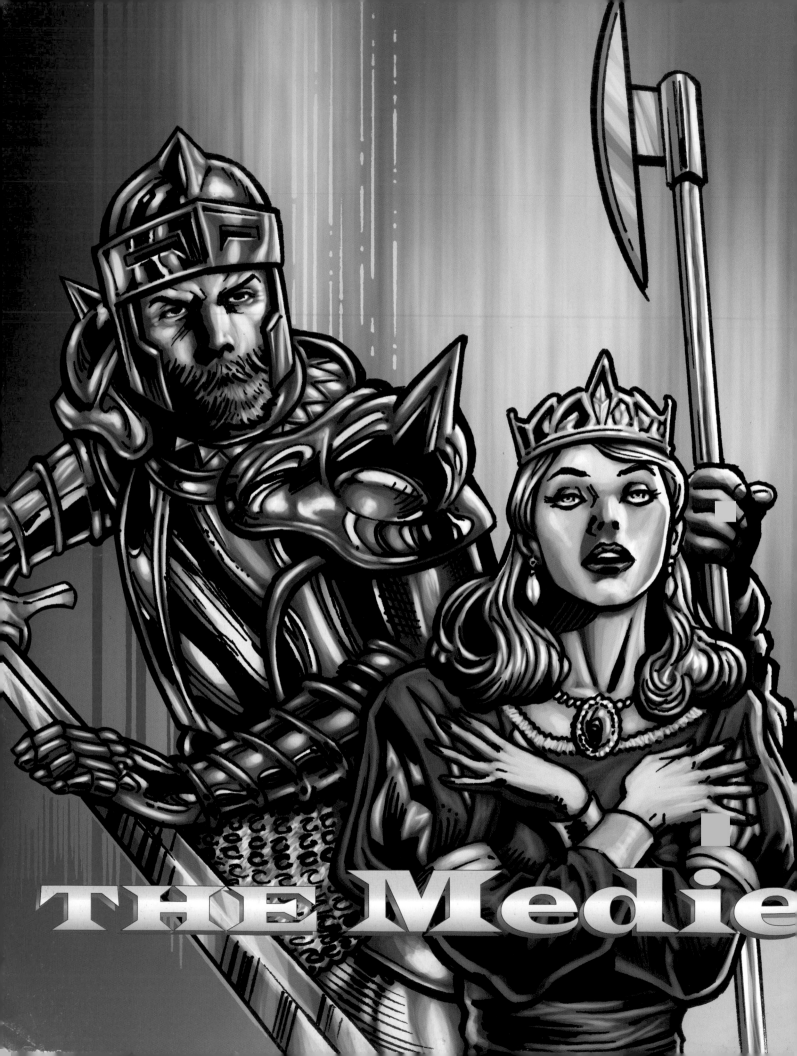

THE Medie

SOME CHARACTERS ARE SO POPULAR, SO "STURDY" in the collective imagination of the general public, that they are reinvented again and again throughout the changing course of artistic styles, but they never die out. Medieval characters fall into this category. Ever since Sir Thomas Malory wrote his now-classic epic saga of King Arthur's adventures, *Le Morte D'Arthur*, in 1485, his transcendent characters have become a part of the human condition, exemplifying love, courage, betrayal, wisdom, honor, cunning, and dark ambition.

valworld

CLASSIC KNIGHT IN ARMOR

A testament to the power of the legend of King Arthur and the knights of the Round Table, *Le Morte D'Arthur* is still available in bookstores and libraries. It's a thick book and a slow but engrossing read—the ultimate medieval tale of heroism, love, and betrayal. All of the characters are represented, major and minor, from Arthur to Merlin, Guinevere to Lancelot, Galahad to Gawain, and, of course, the infamous Morgan Le Fay and her wicked son Mordred. It is these literary figures who are the inspiration for medieval fantasy characters, the most classic of all being the knight. The knight embodied the spirit of courage and honor—for king, God, and the land.

FRONT

Men were smaller in stature in the Middle Ages. If you go to a museum and look at some good examples of armor, you won't see anything for 6-footers. The armor was built for short, stocky warriors. Knights expected to move slowly and fight hard. But the armor at the joints was constructed with breaks to have great flexibility so that swinging motions (for sword attacks) were unimpeded. To this end, chain mail was incorporated into it—for protection at those breaks—as were knee, elbow, and shoulder guards.

Paintings of the era show many knights in full armor but with their helmets removed. Knights probably took them off whenever possible; one can only imagine how uncomfortable they must have been to wear.

Torso section is largest single piece of armor

Guards over breaks in armor at joints

Sizable hip guards

SIDE

At this angle, you can more clearly see the layering of the armor plates on the upper arm areas, hip guards, and boots. Some minimal styles of armor suits were mainly leather combined with chain mail and only a few metal plates. There were trade-offs with armor design: You might sacrifice some body protection to gain the speed that comes with lighter armor. But for the visual artist, the thing to keep in mind is that the more heavily armored the knight is (such as the ones shown here), the more sophisticated, regal, and "legitimate" he will look, like a knight of the Round Table. In other words, a "good guy." Knights in ragtag or dark armor are either bandits or, with horned helmets, worse! Also on "bad guys," the shoulder guards should have severe horns.

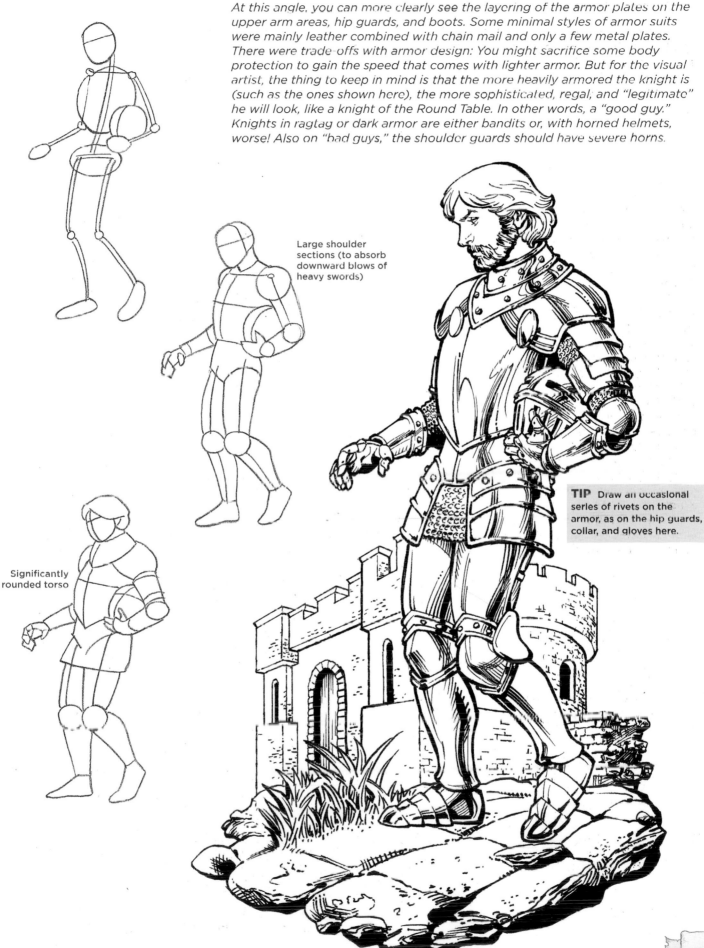

Large shoulder sections (to absorb downward blows of heavy swords)

Significantly rounded torso

TIP Draw an occasional series of rivets on the armor, as on the hip guards, collar, and gloves here.

PRINCESS

The medieval princess is not a synonym for Cinderella. She doesn't wear a silken gown, glass slippers, and a diamond necklace. In the Middle Ages, even the kings and queens lived like dirt compared to how we live today. The castles were cold, damp, and dark. Pigs and goats roamed the dining halls. Do you know why kings wore those robes? Because they were freezing cold in their castles! Kingdoms were often in a state of financial distress, due to the flagrant spending and oppressive taxation brought about by the crusades.

Simple wraparound hat gives her a modest look

Veil over hair

Long, bell-shaped sleeves

Long, ankle-length dress for "proper ladies"

FRONT

The term treated like a princess *didn't have the same meaning back then. Princesses didn't inherit their father's money or estates; in fact, the laws prevented it due to their gender. Princesses were forced to wed princes from other lands to assure peace between warring states. Amid all of this, the princess herself was a fairly powerless individual, tossed about the political chessboard like a pawn. Therefore, it is not surprising that the poor, neglected girl is depicted, for illustrative purposes, as a sweet character, but of modest nature, without much in the way of pageantry. That only comes after she is made queen. The queen did, in the Middle Ages, wield power.*

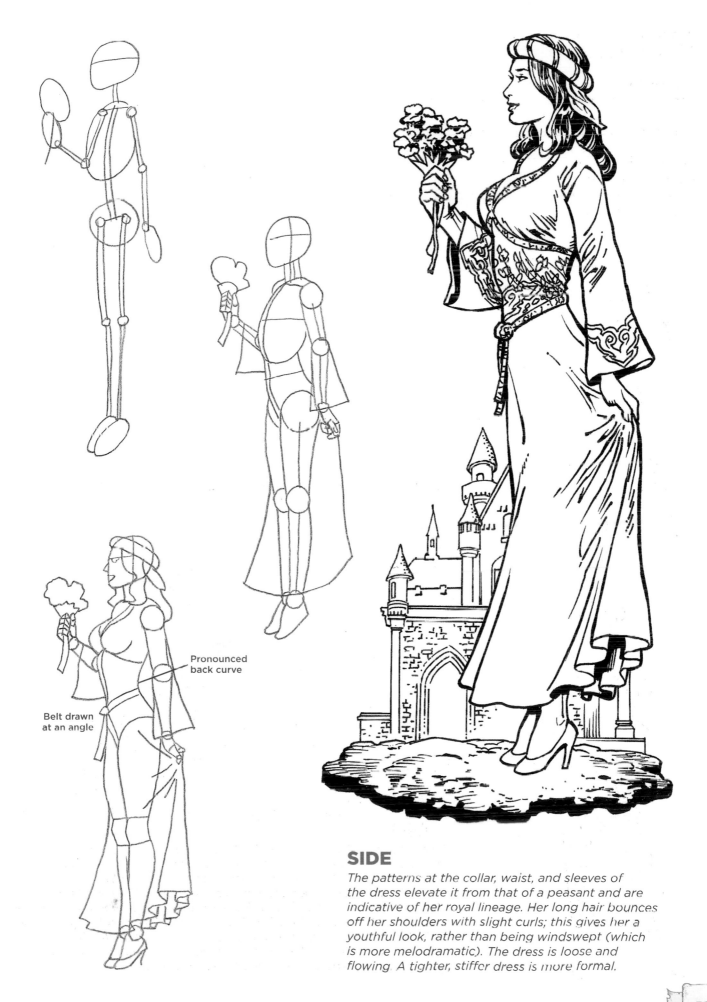

Belt drawn
at an angle

Pronounced
back curve

SIDE

The patterns at the collar, waist, and sleeves of the dress elevate it from that of a peasant and are indicative of her royal lineage. Her long hair bounces off her shoulders with slight curls; this gives her a youthful look, rather than being windswept (which is more melodramatic). The dress is loose and flowing. A tighter, stiffer dress is more formal.

CLASSIC MERLIN-TYPE WIZARD

Half man, half devil, a seer into the future, not of this world, the wizard is an immensely popular character and is easy to draw because of his trademark embellishments. People anticipate seeing the specific hallmarks of this character, which pleases them. When you include these elements, you satisfy audience expectations, and they will immediately recognize the character as Merlin (or a wizard). So, it's about knowing—and not overlooking—the trademark signs of the character and including them in your drawing.

FRONT

Note the arms reaching out, with the fingers spread, casting a spell—a classic wizard pose. Merlin is a towering figure, despite his advanced age. He is a confidante of kings, a mentor, a friend, but he is not the king's subject. He follows his own path.

SIDE

Merlin is a conjuror—he creates out of nothing. As such, his hand gestures are very important. You can gain a lot of mood from pairing the hands together in mysterious positions, as they are in this side view. The hands can cause objects to appear, to rise or fall, or to spin in midair without ever touching them.

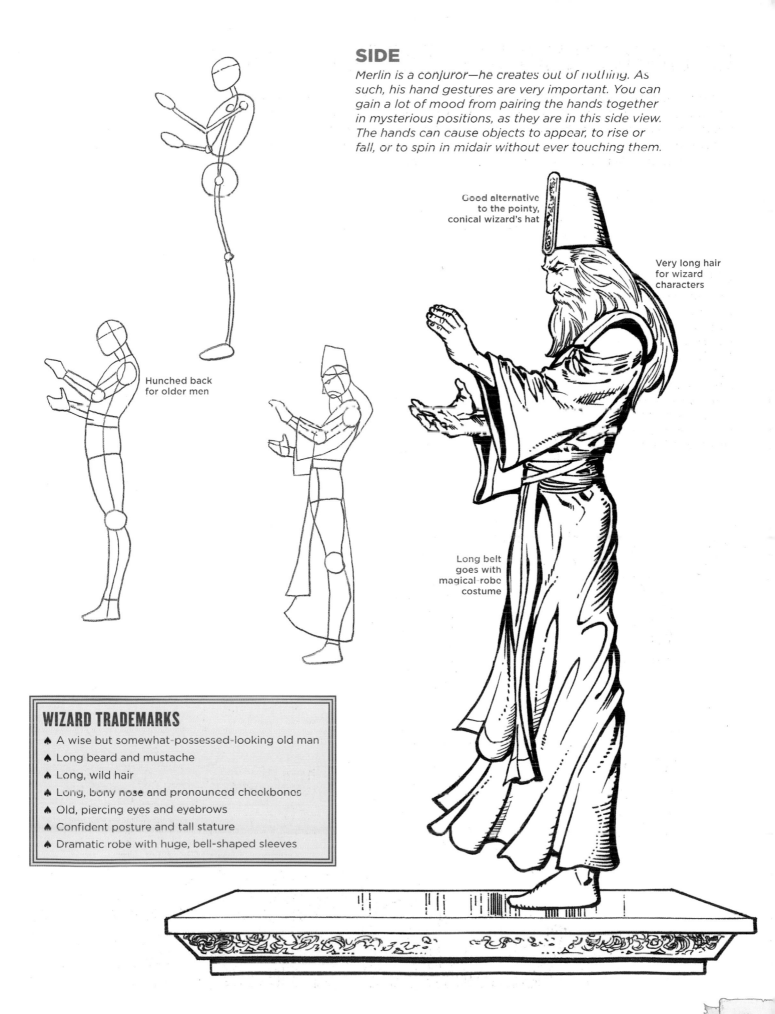

Good alternative to the pointy, conical wizard's hat

Very long hair for wizard characters

Hunched back for older men

Long belt goes with magical-robe costume

WIZARD TRADEMARKS

- ♠ A wise but somewhat-possessed-looking old man
- ♠ Long beard and mustache
- ♠ Long, wild hair
- ♠ Long, bony nose and pronounced cheekbones
- ♠ Old, piercing eyes and eyebrows
- ♠ Confident posture and tall stature
- ♠ Dramatic robe with huge, bell-shaped sleeves

BATTLE HORSES

Horses were a part of everyday life in the Middle Ages, just like dogs are today but even more so. Even if a horse isn't being ridden, it is an excellent "prop" in a scene, just as evocative of the times as a castle—especially when it is wearing knightly horse dress and mask or face armor. If you could shoot an arrow at a knight's horse, you could leave him on foot and vulnerable miles from home—ergo, the armored horse.

To draw the horse, simplify it by dividing its body into three parts: the shoulder, the barrel (torso and belly), and the haunches (hips and rear). Also note the following: The chest protrudes beyond the neck in front. What is referred to as the knee really corresponds to the human wrist. The hock is actually the horse's heel. The knee and the hock fall roughly along the same vertical line. The neck always has a slight upward curve to it.

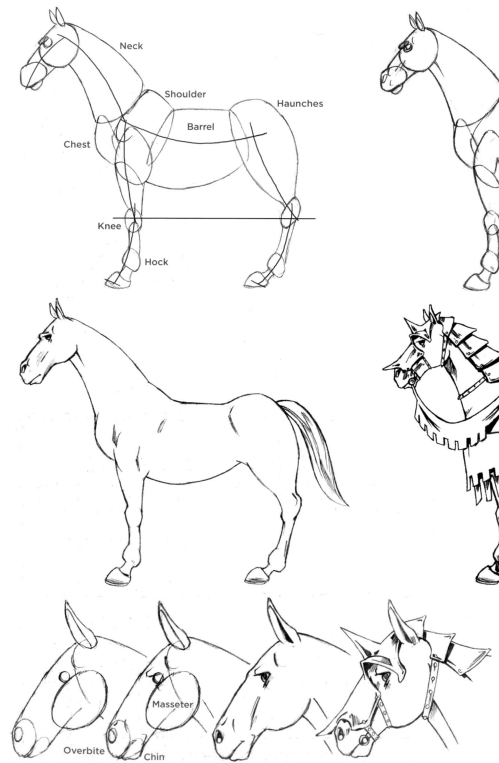

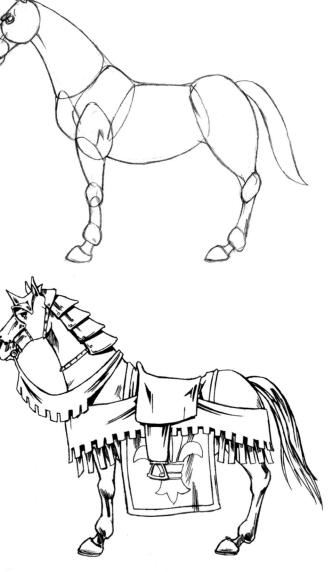

HORSE'S HEAD

The two main areas to focus on are the huge chewing muscle (the masseter) and the rounded chin. Also, the horse has a slight overbite.

SIDE

A HEROIC COMBO

The knight on horseback is a heroic figure in that he is in control of a beast much larger and stronger than himself. If the beast is also loyal to him, and he to it, then we view the hero as kind, as well as courageous.

7/8 REAR

7/8 FRONT

3/4

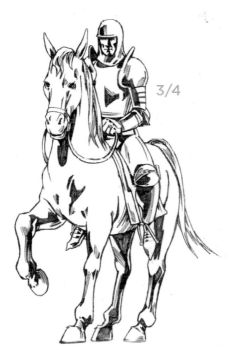

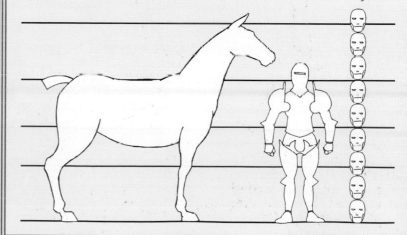

MAN/HORSE HEIGHT COMPARISON

The average man is 6 to 7 heads tall. The horse is 9 heads tall. But horses vary considerably in height, and you can make yours more massive—especially if your knight is a powerful, evil character. The more important landmark to keep in mind for proportions is that the horse's withers—the ridge between the horse's shoulder bones—are at about a man's eye level.

ARMORED AND DECORATED HORSES

There were many reasons for the elaborate costumes in which knights used to dress their horses: ceremonial, for protection, to inspire fear in the enemy, and last but not least, pride of ownership. Medieval men had horses instead of cars. If they'd had fuzzy dice back then, they probably would have hung them on their horses, too.

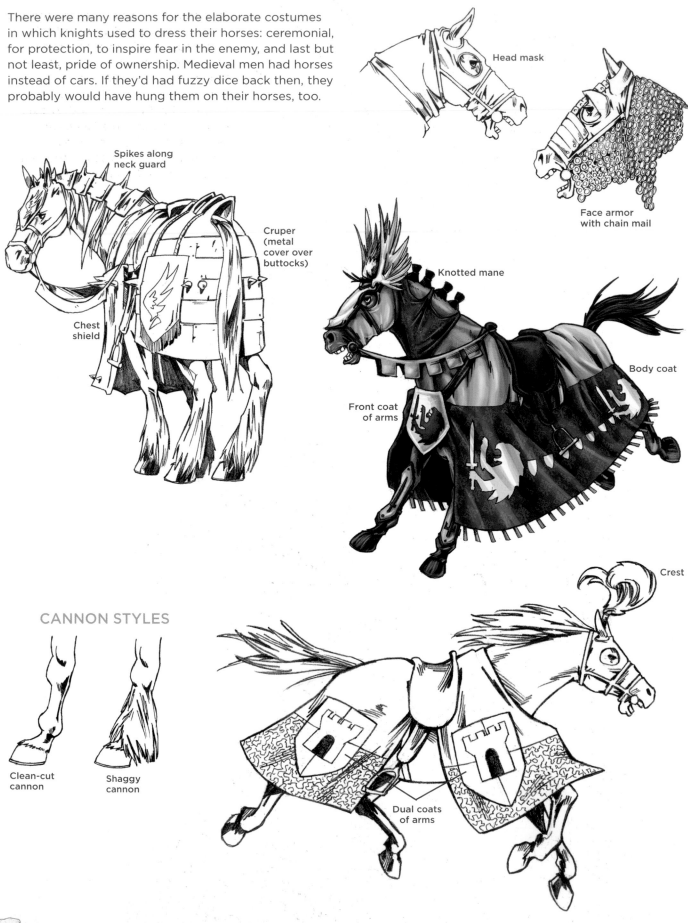

Head mask

Face armor with chain mail

Spikes along neck guard

Cruper (metal cover over buttocks)

Chest shield

Knotted mane

Body coat

Front coat of arms

Crest

CANNON STYLES

Clean-cut cannon

Shaggy cannon

Dual coats of arms

THE MOUNTED ASSAULT

The mounted assault is a jam-packed, powerful scene. But you must take care to prevent it from becoming a confusing mass, since it's a heavily layered piece of illustration by definition. To do so, keep the horses' heads out in front so that they cut a clear silhouette. The lances are kept to the background and are silhouetted, which helps to separate them from the foreground.

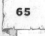

KNIGHT ON HORSEBACK

Note how, when a horse gallops, its legs gather underneath its body. And; just as important, the front hooves angle inward and are relaxed. The rider leans forward, into the attack, in an aggressive posture. The cape trails behind him, adding to the feeling of motion.

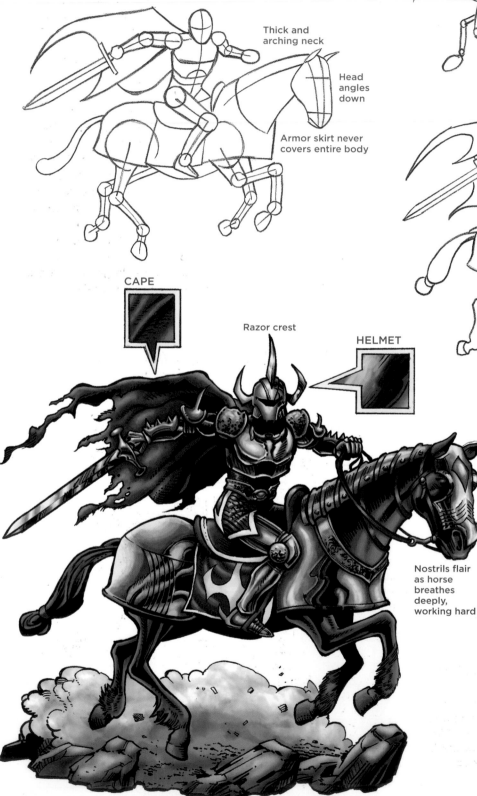

Thick and arching neck

Head angles down

Armor skirt never covers entire body

CAPE

Razor crest

HELMET

Ears perked forward, again showing aggression

Nostrils flair as horse breathes deeply, working hard

RENDERING DETAILS

Note the varied uses of line and shadow to render image details: Broken shadows indicate the underside of the cape. Wavy parallel lines of varying thickness represent the metallic shine of armor, as on the helmets, horns, and torso sections. The ragged edges of the cape—combined with the horned helmet, the spikes on the elbow guards, and the overall darkness of the armor—clearly define the character as a killer. This horn-helmeted character on horseback is a classic, sometimes referred to as the Black Knight.

SQVIRE'S DVTIES

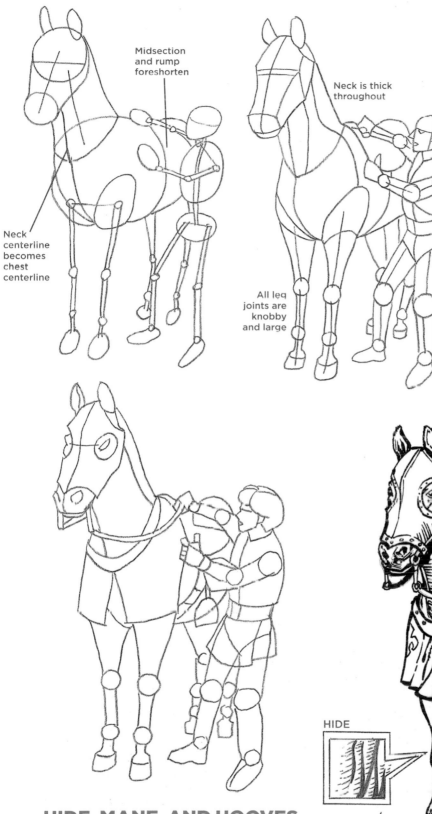

Midsection and rump foreshorten

Neck centerline becomes chest centerline

Neck is thick throughout

All leg joints are knobby and large

The squire saddled up his master's steed and was in charge of its upkeep. Great care was taken with the horse. Horses were constantly brushed and had their saddles removed when not in use so that they didn't get sores. Horseshoes were necessary to protect the rims of the horse's hooves as the horses supported the weight of the armored warrior.

The horse here is shown in the 3/4 view, and there are a few things to note when drawing this angle: The centerline of the neck becomes the centerline of the chest, dividing the chest into two sets of chest muscles, just like on humans. The neck is thick throughout, from top to bottom; there is no area where it becomes slender. And, from this angle, the midsection and rump quickly foreshorten (become compressed) due to the effects of perspective (the fact that near objects appear large while more distant objects appear smaller).

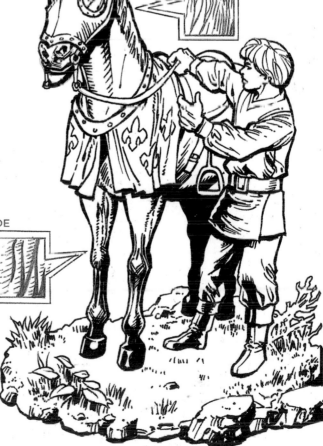

HAIR

HIDE

HIDE, MANE, AND HOOVES

Draw horse hide as small, repeated horizontal sketch lines over long, vertical muscles. To indicate the actual hair on the hide, use clusters of fine vertical lines. For hooves, use pools of black broken up with small white areas to designate highlights.

PEASANT LIFE

Whenever an appliance in my house stops working, I call "the guy." I don't know who the guy is, but he wears a uniform, fixes whatever is broken, sends me the bill, and everyone is happy. In the Middle Ages, there was no "guy." Whoever you were back then, you were The Guy. If you wanted to eat, you were the "hunting guy." You wanted wood? You were the "chopping guy." You needed a house? Guess who was the architect?

Castles were made of stone, but peasants lived in houses made of wood with thatched roofs. It's amazing, but in Europe, some thatched-roof homes from the Middle Ages still exist in good condition. Of course, you didn't dare chop down a tree from the king's forest to make your modest dwelling. Messing with anything from the king's forest was serious trouble. Hunting one of "his" deer meant you were subject to the death penalty. That's a historical fact of medieval law.

Peasants are short, not well nourished. Their diminutive stature is a visual metaphor for their oppression by the king.

WOOD AND PEASANT CLOTHING

Wood requires some concentric knots amid horizontal sketch lines; the cut edge is created by drawing a spiral line. As to the garments, for illustrators, the thing that most brings out the flavor of the lower classes is the stitching in their modest clothing. It should be overt and can be used on anything: upper garments, hats, boots, capes, and coats. Stitches are two pieces of string, each with some thickness, which hold two parts of clothing together.

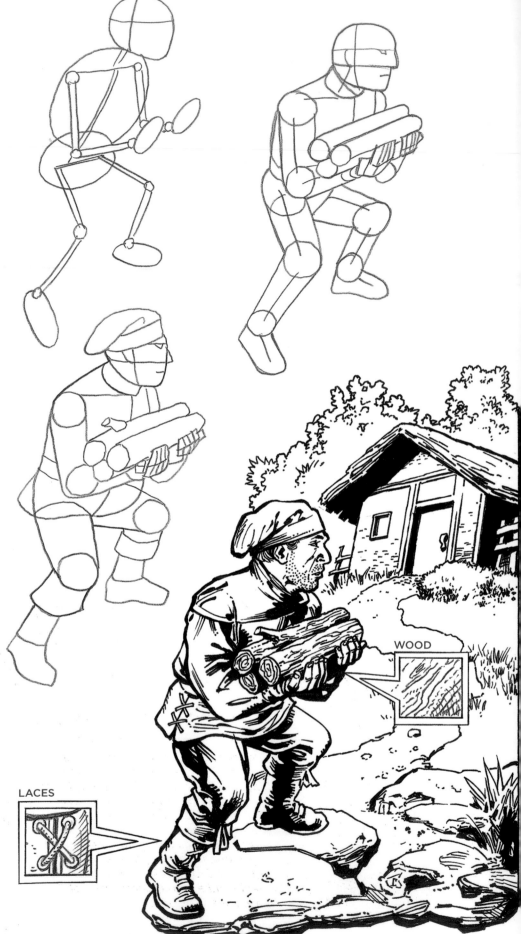

WOOD

LACES

THE POWERFUL SORCERER

It really doesn't matter what design pattern you use to decorate the robe of the wizard. Just use something. The problem with leaving the hems unembellished is that the garment then ends up looking like a bathrobe. But, the moment you decorate the trim with a repeated pattern, it takes on a dark, mysterious flair.

The staff is also an important element of the costume; it's not a wand, which is for magicians who saw ladies in two. Remember, the wizard is a master of manipulating the forces of nature (which fascinated medieval man), as evidenced by his intense interest in alchemy (the notorious promise of, among other things, turning ordinary metals into gold). The staff, with its huge amulet at its zenith, acts as a lightning rod, gathering the energies of the earth to create magic—the secrets of which only the wizard knows.

REFLECTIVE SURFACE

Tip of staff must have interestingly designed ornament

Show interior of sleeve

DECORATIVE EDGING

Wide collar for authoritative figures

Pointed shoes are a sign of magic

REFLECTIVE SURFACES AND FABRIC FOLDS

Reflective surfaces are drawn with alternating straight, thick, and thin inked streaks. The light areas indicate the highlights or places where light reflects off the shiny surfaces. For fabric, a repeated pattern for the hems of robes creates a mysterious garment. Repeated, overlapping folds give the fabric a rich and also active feel—and are an essential part of a wizard's costume.

TEXTURE IN THE MIDDLE AGES

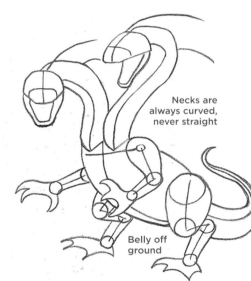

The Middle Ages were an age characterized by hardship. Life was difficult. Everything was built by hand, either chopped or sewn or stitched. The world was a tactile one, not the impersonal environment of glass and concrete that we have today. Things were bumpy, not smooth. The ground was made of dirt and gravel. There were no asphalt roads.

By bringing out the rough textures in the clothes and other things in a scene, you draw the audience into the experience of *a time long ago*, a time when knights battled dragons and the Holy Grail lay just over the horizon. Textures make things look real. Whether you're drawing the scaly skin of giant lizards or dragons, the shining long swords of classic knights, or the boots of peasant woodsmen, you give your drawings an edge by texturing the surfaces.

TIP Anyplace you can show the markings on the underbelly, do it. It's very dramatic.

Necks are always curved, never straight

Belly off ground

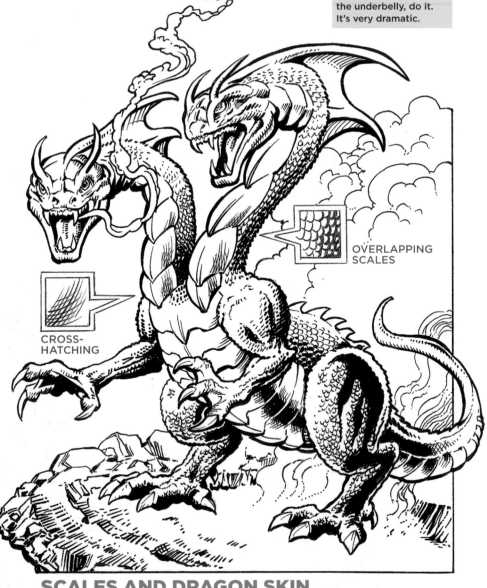

CROSS-HATCHING

OVERLAPPING SCALES

Birdlike feet—with large claws—spread apart to support body weight

SCALES AND DRAGON SKIN

If a dragon is an awesome character, just think how formidable a dragon with two heads is! These are truly spectacular characters. The scaly texture of the dragon's skin is a significant feature. Another important note: When the dragon attacks, its body rises off the ground, propped up by its enormous thigh muscles.

TEXTURAL VARIETY

Everybody's always after the pretty girl. What's a fantasy princess to do? Ogre or no ogre, I'm betting on the character with the lip gloss and the big sword. This scene has a great variety of textures. Imagine how much less engrossing the scene would be if all the textures were ignored and, instead, the lines were all drawn smoothly and evenly? It would begin to lose the feeling of danger. In fact, it would start to look a little bouncy, like a cartoon. Don't want that—not in a heroic fantasy drawing.

This scene makes use of a number of different textures. The wild, wolflike fur used on the surface of arms, the legs, and the back of monster characters makes them appear more animalistic. Folds in clothing require lines that are thick to indicate pockets of shadow. Drawing some depth in the folds makes the character look three-dimensional. Stones have a "grain" to them, just like trees, except that the rendering is straighter. The foliage and ground also exhibit various textures.

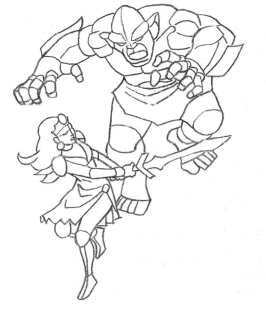

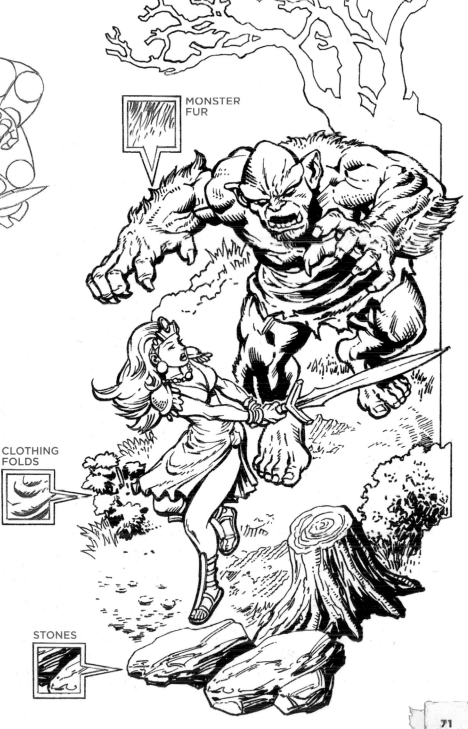

MONSTER FUR

CLOTHING FOLDS

STONES

WEAPONRY FOR HAND-TO-HAND COMBAT

Fantasy art borrows heavily from the Middle Ages, especially when it comes to warfare and hand-to-hand combat. That's because the weapons of the medieval period were inventive, visually impressive, and highly effective. It was one of the few areas in which the scientific method was employed: Trial and error prevailed, rather than dogma. As a result, more robust and deadlier devices continued to be introduced. Each had its own purpose for a particular stage of battle: Some would slash, some would chop, some would smash, some would rip, and so on. Training was a very important part of a knight's daily activity. Battle wasn't looked upon solely as a duty, but as a reward—a chance to prove one's manhood and gain honor.

In fantasy illustration, characters are often given multiple weapons; therefore, we tend to see characters who are not only archers but also swordsmen and experts with other devices, as well. This is a departure from medieval history but makes the heroes look all the more battle-ready and awesome.

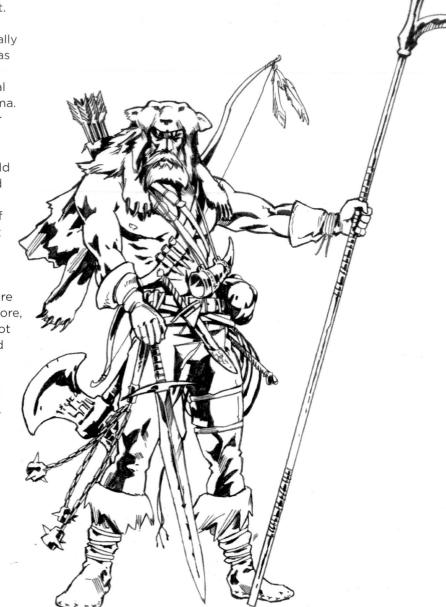

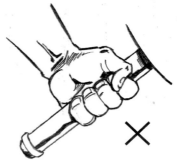

When gripping a handle, the fingers do not wrap around the entire cylinder. . . .

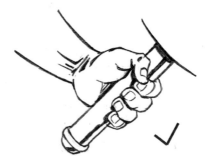

. . . Instead, some of the handle should still be visible between the ends of the fingers and the palm.

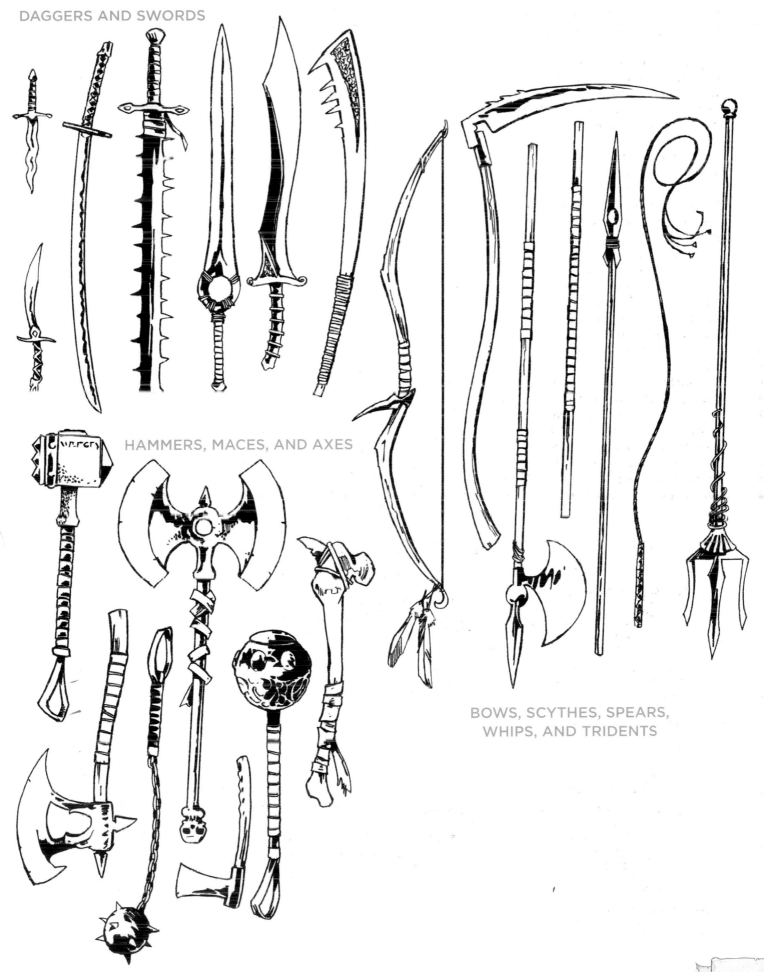

DAGGERS AND SWORDS

HAMMERS, MACES, AND AXES

BOWS, SCYTHES, SPEARS,
WHIPS, AND TRIDENTS

SIEGE MACHINES

The big, multi-manned machines are called *siege* weapons because they're used in a siege, to bring down a castle. An invading army is usually not far behind them to make use of any opening created by the smashing of the fortress. (Note that the giant crossbow can be fitted with a fire-tipped arrow, setting the castle ablaze.)

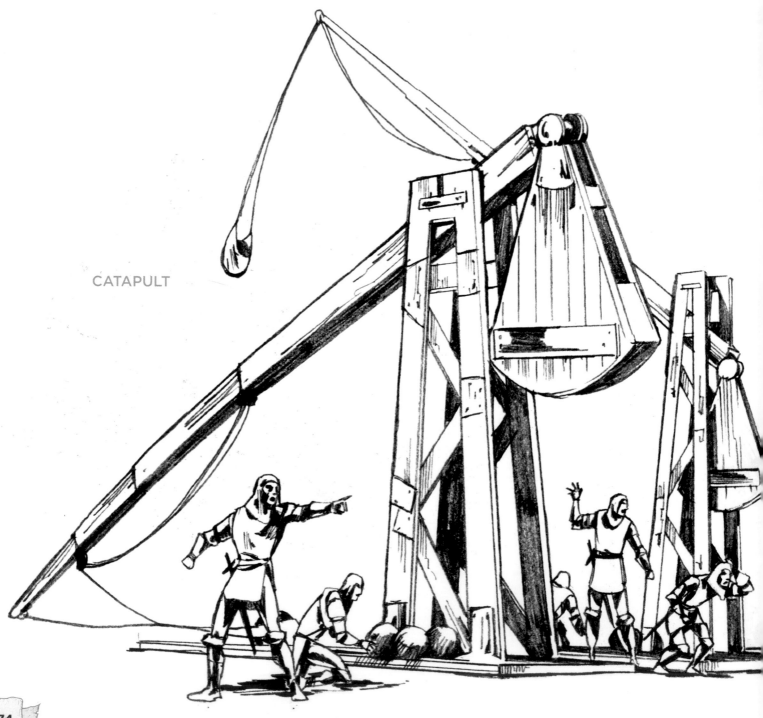

CATAPULT

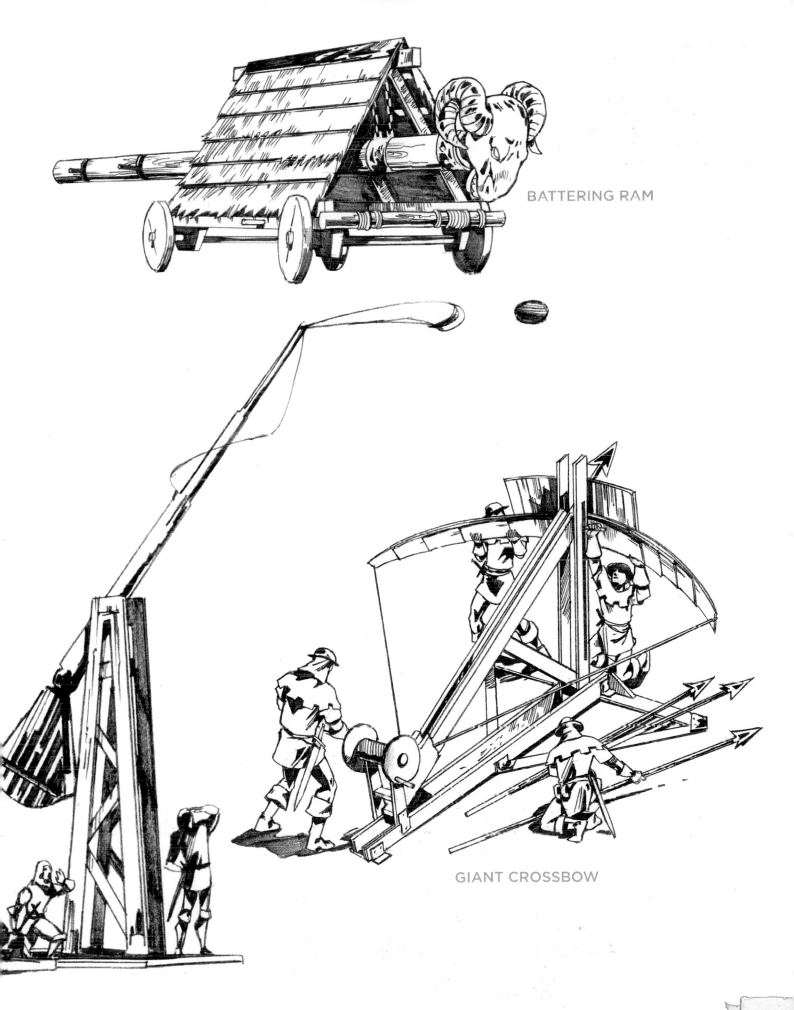

BATTERING RAM

GIANT CROSSBOW

HOODED ASSASSIN

Assassinations were a fixture throughout the Middle Ages. Thomas Becket (1118–1170), the archbishop of Canterbury, met his end by the sword when four of King Henry II's henchmen paid him a visit, after which Thomas Becket found himself very much dead.

Sons and nephews of kings were notorious for having their fathers and uncles killed. These were the original dysfunctional families. The problem lay in the fact that by the age of six, most of the royal children were taken from their parents to live with scholars who would tutor them but were virtual strangers. The children would then return to the court to see their parents again when they were young adults. There was no connection between them, only a hunger for their father's inheritance. In fact, the only reason the royals had children was to quash the unrest of the people if they did not produce an heir.

There was, however, no specific career profession known as "assassin," only knights assigned, in groups, to carry out killings or to overthrow kingdoms. In the fantasy genre, character types are borrowed and combined to create even stronger figures. So, the ever-present figure of Death (depicted in many paintings due to the ubiquitous nature of the Black Plague) is combined with the avenging knight to produce a single character: the medieval assassin.

This is a powerful and fearsome figure, with a dark, almost supernatural quality about him. When he appears, death permeates the room. Create a ghostly look in his eyes by blackening the area underneath them, almost like a mask, but leaving the rest of his face white; the contrast makes him look corpselike. A dagger, an instrument of murder, appears not in one hand, but two. The hood and cape are drawn with a black exterior.

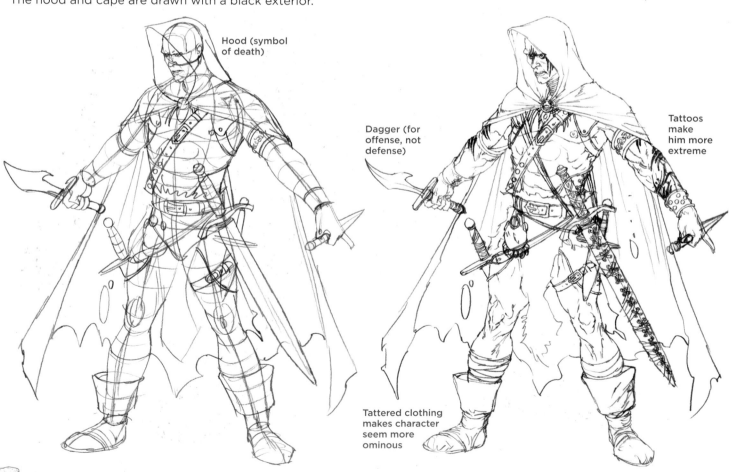

Head tilts forward, creating a strong pose

Hood (symbol of death)

Dagger (for offense, not defense)

Tattoos make him more extreme

Tattered clothing makes character seem more ominous

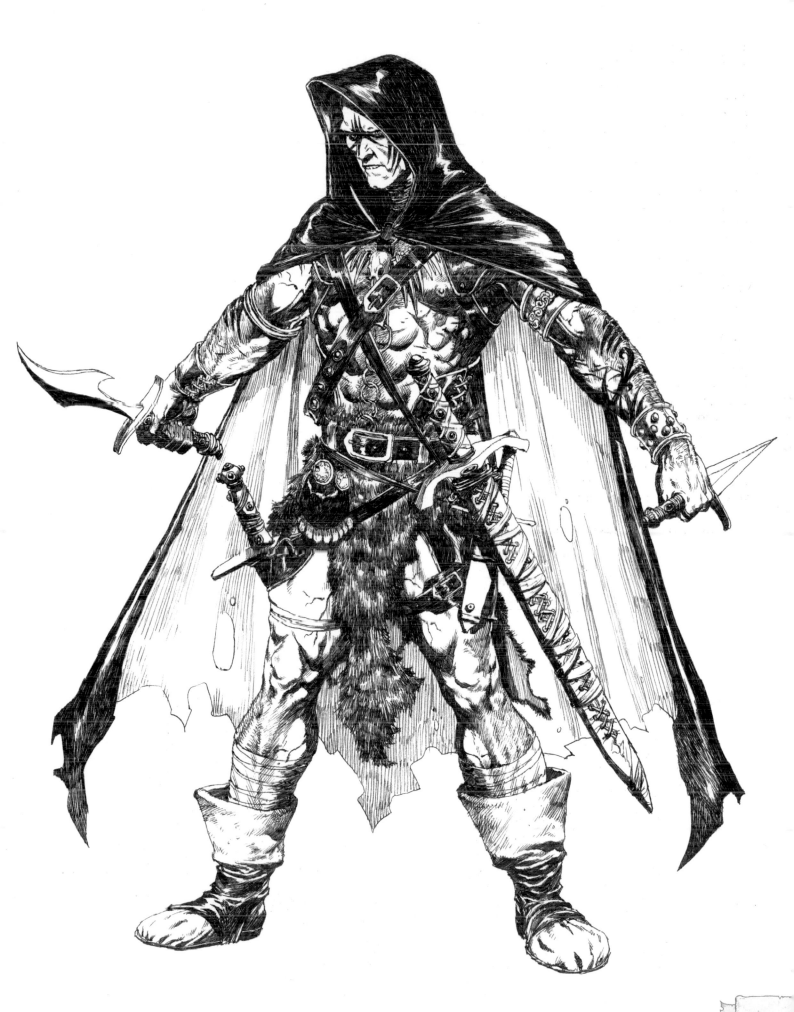

CLASSIC SWORDFIGHT POSES

The sword is more than merely a weapon in the fantasy genre, it is a character in and of itself. King Arthur's sword even had its own name: Excalibur. Such is the importance given to the knight's sword. Squires were knighted when the king made a ceremonial tap on each shoulder with a sword. A great majority of popular fantasy characters, especially heroes, lived and died by the sword. Readers and movie audiences anticipate great climactic scenes with swordfights, whether they are knights, pirates, Vikings, or some amalgam of fantasy warriors.

The challenge to drawing swordfighting scenes lies in drawing not one but two people involved in armed struggle. A fistfight is easy by comparison. In a fistfight, you can draw one person punching and the other reeling back. But in a swordfight, even if one person is thrusting, the other is parrying; so, both are using fighting maneuvers at the same time, and with all those diagonal lines of the blades, the drawing can potentially get complicated. The classic swordfighting poses keep the body positions basic enough to read while remaining exciting.

BRACED FOR COMBAT

The stance is wide and firm, ready to take on whatever challenge awaits. Brash and heroic, the knight is, of course, famous for his armor, and this drawing provides a good view of it: You can see how the dark chain mail alternates between the lighter shade of armor, creating contrast.

DEFENDING

When defending, the shield is out in front, held high, with the body crouched to absorb the blow. The sword is prepared to counter.

STRIKING FROM ABOVE

The sword is held high overhead. Striking down at the enemy is a superior, dominant position. A note about foot position here: Like a baseball player about to throw a ball, the swordsman holds the sword back in one hand while his opposite foot is forward.

COMBINING SWORDFIGHT FIGURES

Classic poses are snapshots of the most exciting moments in an action scene. When drawing an action scene, cut to the chase. Go right to the classic poses first. Go from exciting beat to exciting beat, and dump all the stuff in between.

CLASHING SWORDS

Note that not every pose in defense of a sword attack involves the use of a shield. Two swords clashing is very dramatic—like a struggle of wills, with very dangerous consequences for the one who loses.

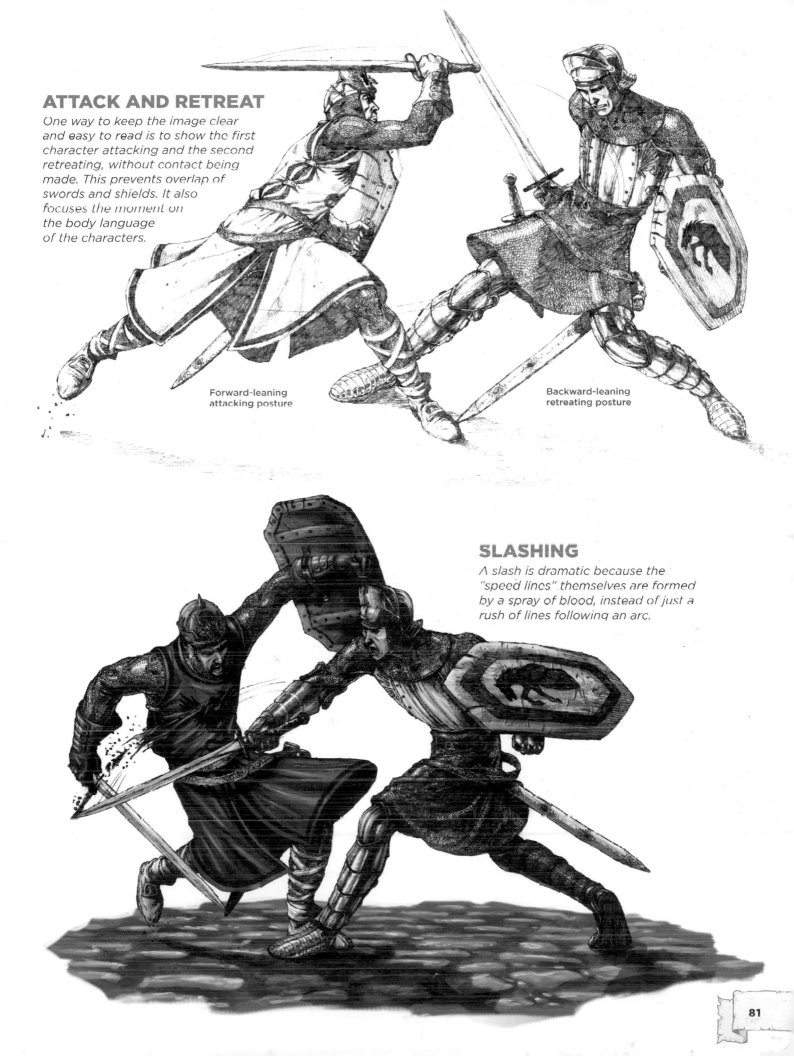

ATTACK AND RETREAT

One way to keep the image clear and easy to read is to show the first character attacking and the second retreating, without contact being made. This prevents overlap of swords and shields. It also focuses the moment on the body language of the characters.

Forward-leaning attacking posture

Backward-leaning retreating posture

SLASHING

A slash is dramatic because the "speed lines" themselves are formed by a spray of blood, instead of just a rush of lines following an arc.

TIMELESS MEDIEVAL FANTASY ELEMENTS

In addition to creating fantastic action scenes, classic poses can also be used to define character types: magical wizard, courageous warrior, humble servant of the kingdom. These traits coalesce around classic poses and postures.

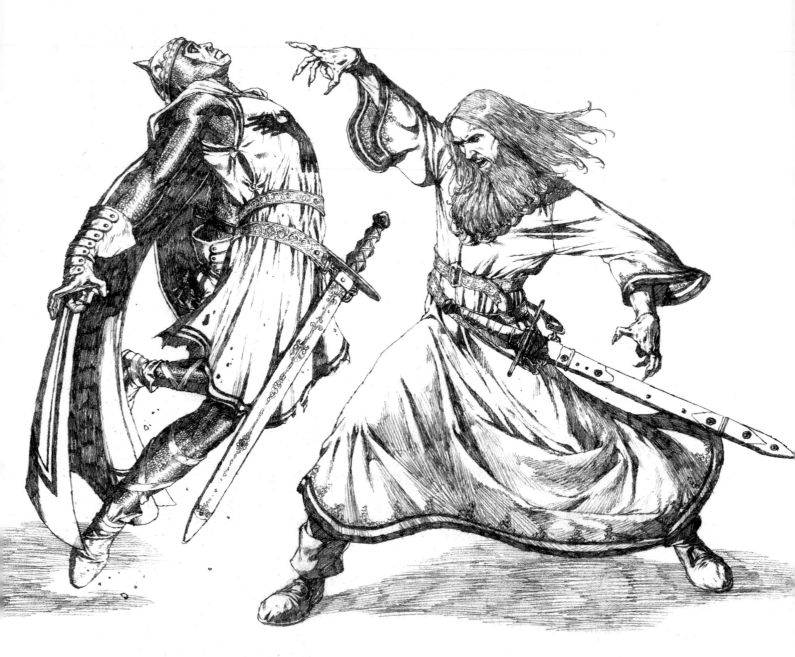

THE WIZARD'S POWERS

In lots of kids' books nowadays, the wizard is a sweet and fuzzy character. But in the exciting world of heroic fantasy art, this mercurial character can be angry and wrathful. Remember, according to some versions of the legend, the famous character Merlin, who started it all, was part devil. The wizard wears a robe with giant belled sleeves and has a tremendous beard, sunken cheeks, and long hair. The conical fairy hat, though not essential, is an appealing design element if you choose to use it.

LEVITATION HINT

When a dark form of magic causes a person to rise from the ground, it pulls the victim up from the chest, as if from the heart, robbing him of all his will, and he remains "asleep," in a trancelike state.

THE JOUST

Jousting began as training for knights. It later became a sport (on which people gambled) at the close of the Middle Ages. Rarely, however, were jousts actually fights to the death.

That concept is reserved for folklore that many people mistakenly believe to be factual. Audiences enjoy the drama of the joust as the medieval equivalent of a shootout at the O.K. Corral, usually for the honor of the princess, the most famous of whom was Guinevere. Note how the knight leans forward in the direction of the lance. He doesn't sit straight up, which would make him appear too casual.

TROUBLING REPORTS FROM THE FIELD

Warfare was a way of life in the Middle Ages. Everyone invaded everyone else, all the time. They had no TV, so they had to do something, I guess. News from the battlefield traveled slowly. If some of the king's lands were sacked, the surviving knights would have to ride for days in order to report the catastrophe back home. The king would then be forced to decide whether to gather enough men to launch an effective counterattack or, failing that, offer to buy off his attackers with a ruinous bribe. Kneeling—here while delivering the bad news—is the knight's posture of humility.

DEATH AND THE DRAGON

Even though knights were heroes and were well protected by all their armor, they were not invulnerable or immortal. They could be taken down by something as small as an arrow or as intimidating as a dragon.

DEATH FROM AN ARCHER'S ARROW

Note the angle at which the arrow has hit the knight. This is the correct angle. The whole point of arrows was the ability to shoot them from a distance. Archers shot their arrows skyward, and as they fell downward with increasing speed, they plunged into the necks and chests of the invading knights. Chain mail was incomplete protection against such a sharp projectile. But even a nonlethal arrow strike could be fatal. Richard the Lionheart suffered a nonlethal wound from an arrow. It was removed, but the wound became gangrenous and he died. Before the days of antibiotics, even an infected cut could be a life-threatening injury.

Note the severe reaction from the assaulted knight. His body seizes up, contracting in pain, which greatly conveys the emotion of the scene. An arrow does not cause the body to fling backward, as a blow from a sword or a punch would.

THE DRAGON

In the kingdom of fantasy, one beast rules all: the dragon. At once feared and respected, dragons are masters of sky and land. Of course, we're all familiar with their huge, spinelike wings; sharp teeth; and horned backs. But also take note of their giant claws and the horns coming out from all angles on their skulls. The neck on all dragons is also unusually long—much longer than it is on lizards, to which they are often compared.

THE MEDIEVAL CASTLE

Medieval castles were built on a rocky foundation at the base of a hill, sometimes overlooking the water. This is accurate historically, and also visually quite dramatic for our purposes. Only one precarious bridge connects the castle to the mainland, leaving any approaching figures exposed and vulnerable to scrutiny.

The low angle is the most imposing shot for a castle. You can see how the two sets of gridlike vanishing lines, or guidelines, become quite helpful when drawing such a geometrical structure as the medieval castle. Note the conical "caps" atop each tower and the spires that continue upward, some with flags posted at the very top. The uppermost tower is isolated, mysterious—and belongs to the wizard.

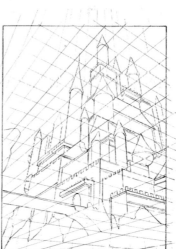

Gridlike sets of vanishing lines are superimposed over the picture plane and function as a guide for the artist to get the structure right.

Highest, most isolated tower for the resident wizard

High vantage point to spot approaching enemies

Give flags an emblem

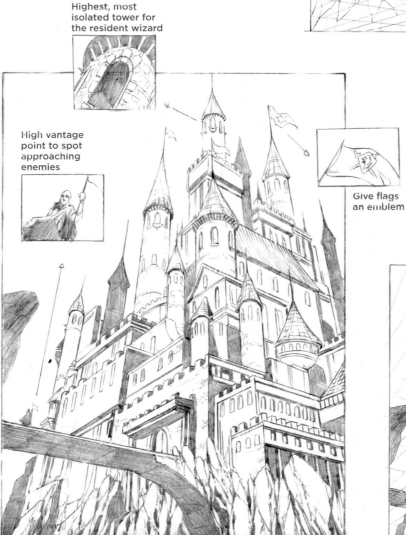

Bridge is only entryway

Castle sits atop steep crags

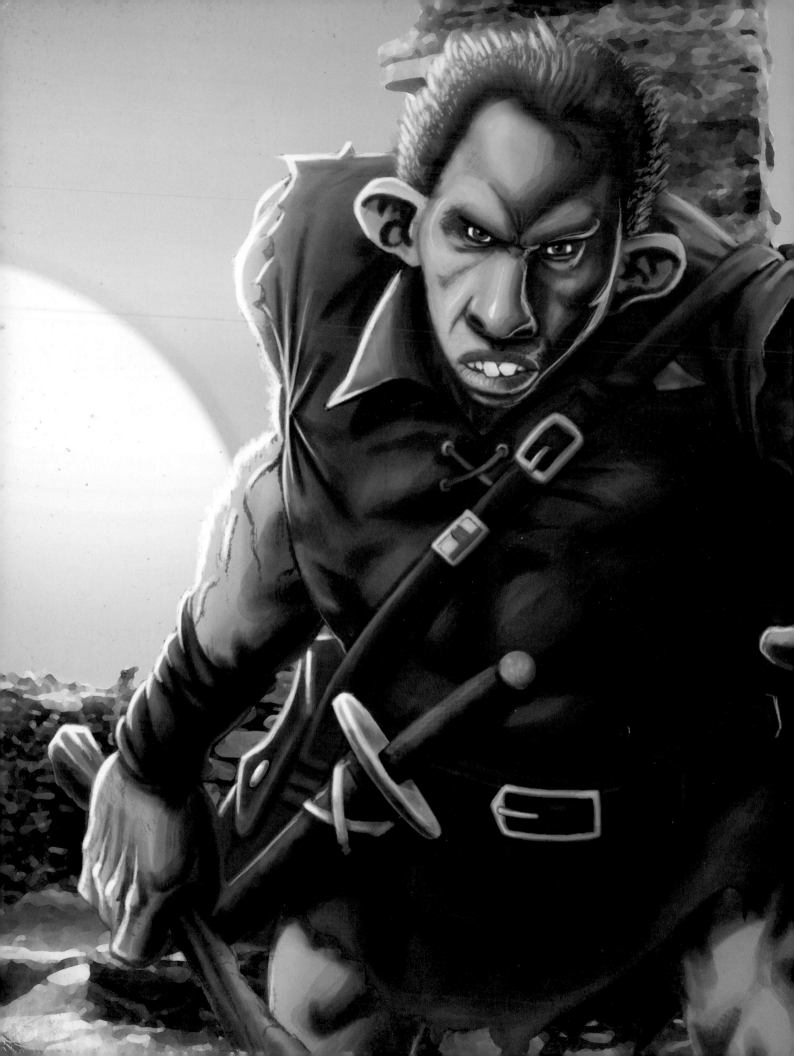

WILD THINGS!

AT THIS NEXT STOP ON OUR JOURNEY into the world of fantasy, there will be man-beasts, ogres, and trolls. As we trek deeper into the forest, we will come upon ancient cities and discover the wicked creatures that inhabit them. This, and much more, shall all be yours as we continue on an enchanted voyage into the realm of darkness, magic, and myth.

MAN-BEASTS

The darker world of the fantasy genre—especially the barbarian arena—is inhabited by strange, cursed creatures who are more beast than man. In the fantasy world, agrarian- and carnivore-hybrid creatures are equally fierce. They can have goat-type legs, like Pan (the classic Greek god of pastures, flocks, and shepherds), or horse legs, like a centaur.

GOAT HEAD CONSTRUCTION
The goat head is thinner than the steer head, closer to a true triangle.

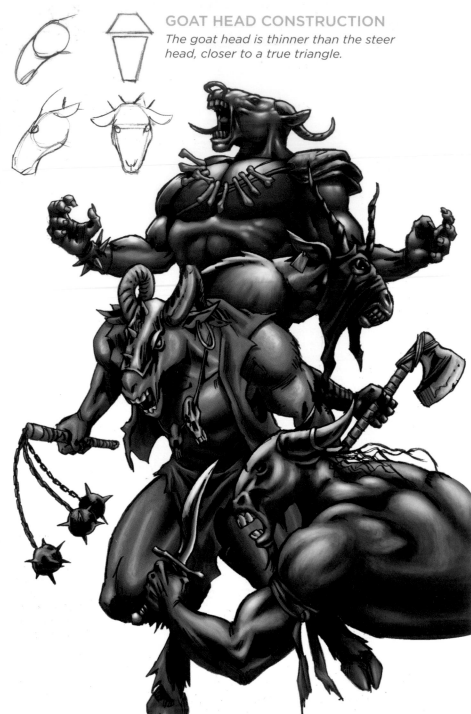

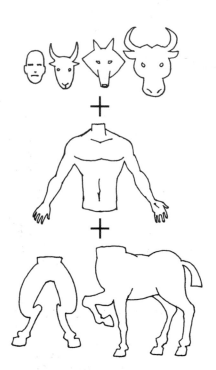

POSSIBLE COMBOS

Given the number of interesting creatures out there in the animal world, you've got a wealth of possible combinations from which to choose for your man-beast characters.

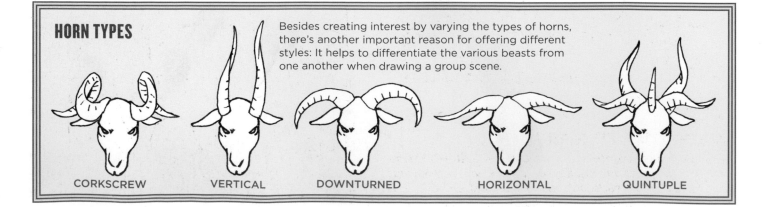

HORN TYPES

Besides creating interest by varying the types of horns, there's another important reason for offering different styles: It helps to differentiate the various beasts from one another when drawing a group scene.

CORKSCREW VERTICAL DOWNTURNED HORIZONTAL QUINTUPLE

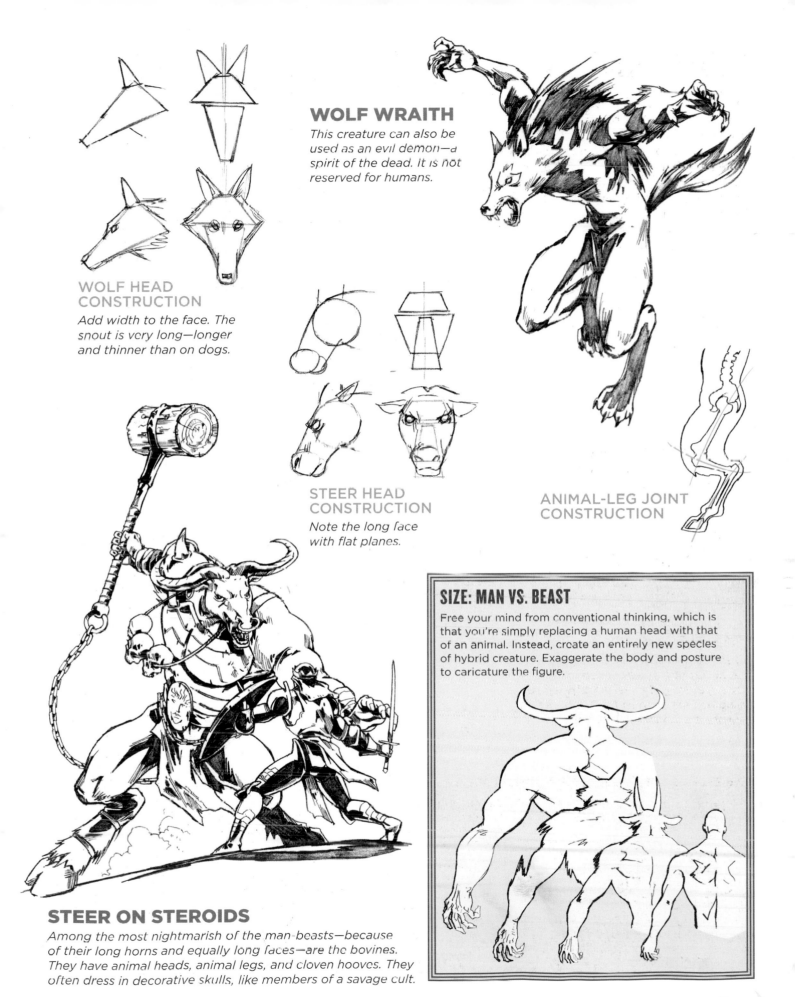

WOLF WRAITH

This creature can also be used as an evil demon—a spirit of the dead. It is not reserved for humans.

WOLF HEAD CONSTRUCTION

Add width to the face. The snout is very long—longer and thinner than on dogs.

STEER HEAD CONSTRUCTION

Note the long face with flat planes.

ANIMAL-LEG JOINT CONSTRUCTION

STEER ON STEROIDS

Among the most nightmarish of the man-beasts—because of their long horns and equally long faces—are the bovines. They have animal heads, animal legs, and cloven hooves. They often dress in decorative skulls, like members of a savage cult.

SIZE: MAN VS. BEAST

Free your mind from conventional thinking, which is that you're simply replacing a human head with that of an animal. Instead, create an entirely new species of hybrid creature. Exaggerate the body and posture to caricature the figure.

REPTILIAN BEASTS

Even further removed from human form are the reptilian beasts. They appear in the barbarian and medieval fantasy worlds. Due to their scaly skin and cold-blooded appearance, they seem almost alien to us, as well as unpredictable. These slithering creatures can be drawn in several degrees of "evolution" away from humans.

EVOLUTION FROM MAN TO LIZARD-BEAST

EVO-LIZARD

More removed from humans in the evolutionary progression, the neck is always bent backward in a lizardlike fashion. The knees bend forward, with the tail in back acting as a counterweight.

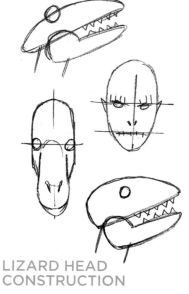

LIZARD HEAD CONSTRUCTION

LIZARD-SNAKE

This baby is all reptile, but which one? Striations across the belly mimic those of a snake.

MUTANT TYPE

Perhaps the most human looking, note the two nostrils that replace a protruding human nose. The lips are cracked and parched.

SKIN PATTERNS

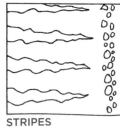

STRIPES

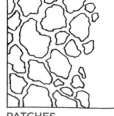

PATCHES

SCALES AND RIBBING

AQUA-CREATURE

Aqua-creatures appear in barbarian, Viking, and medieval fantasy worlds. In addition to the tail and fins, a profusion of spines flair out all over the body, creating an aquatic appearance. Mirroring a fish, the nose is eliminated, the lips are enlarged, and gills appear on the sides of the neck. Sets of side fins form as outgrowths along the length of the body.

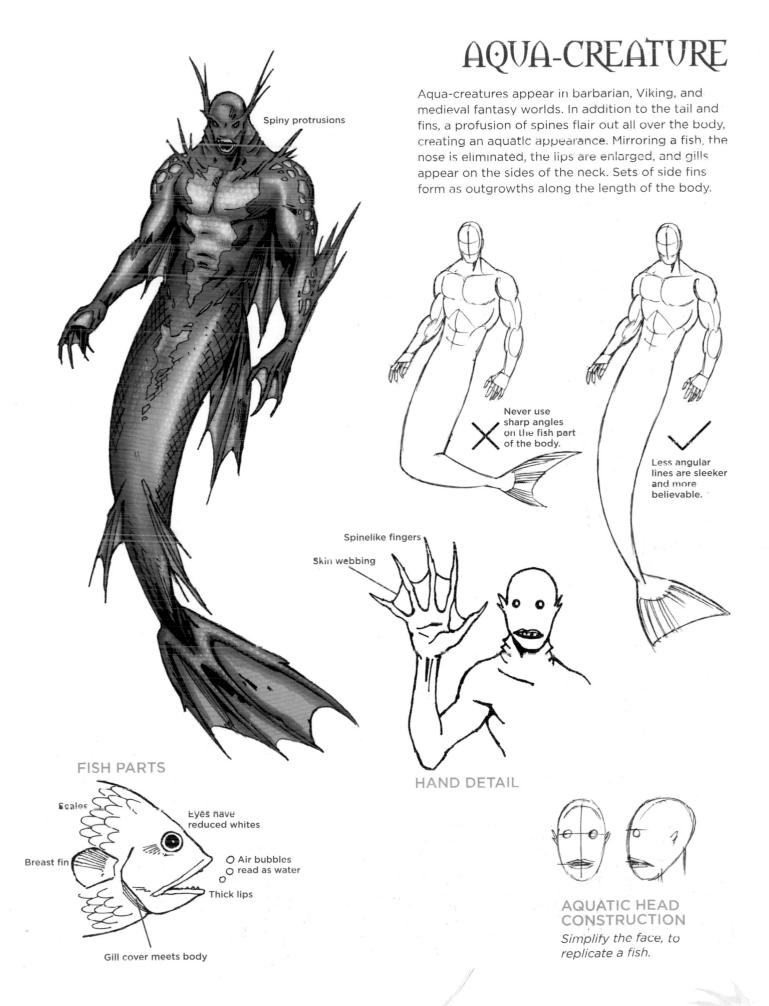

Spiny protrusions

Never use sharp angles on the fish part of the body.

Less angular lines are sleeker and more believable.

Spinelike fingers

Skin webbing

HAND DETAIL

FISH PARTS

Scales

Eyes have reduced whites

Breast fin

○ Air bubbles
○ read as water

Thick lips

Gill cover meets body

AQUATIC HEAD CONSTRUCTION

Simplify the face, to replicate a fish.

HERMIT GIANT

Living alone in the forest for years and years, the giant's beard grows long, his hair turns into a mane, and his clothes become rough and weathered. He's a wild, vicious foe who uses his brute strength and towering height to clear a path wherever he goes. He is drawn not just taller, but thicker and more muscular all the way around. Notice how slender the average knight looks in comparison. The animal skins he wears also serve to give him a feral appearance.

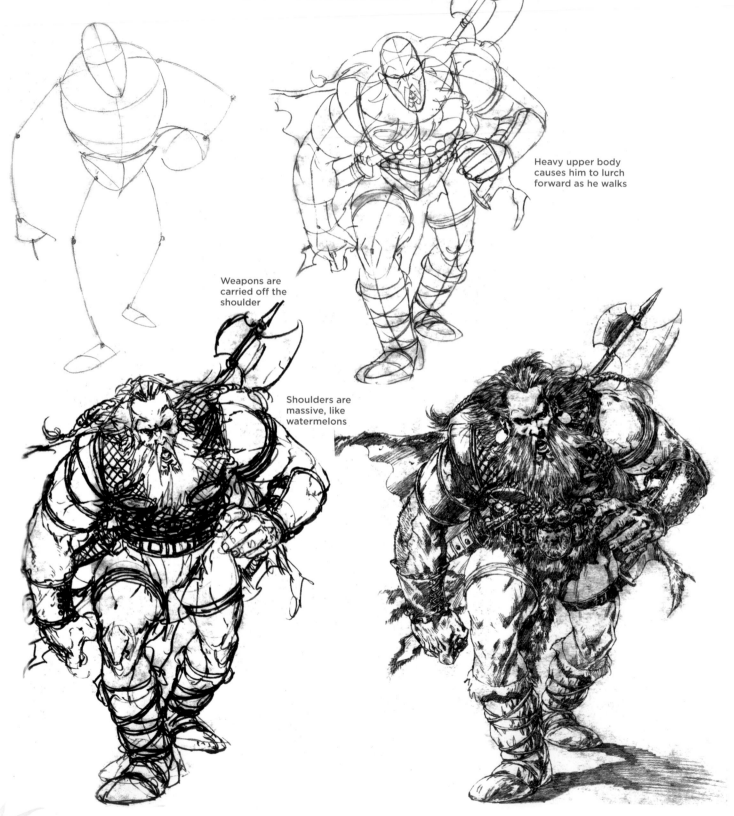

Heavy upper body causes him to lurch forward as he walks

Weapons are carried off the shoulder

Shoulders are massive, like watermelons

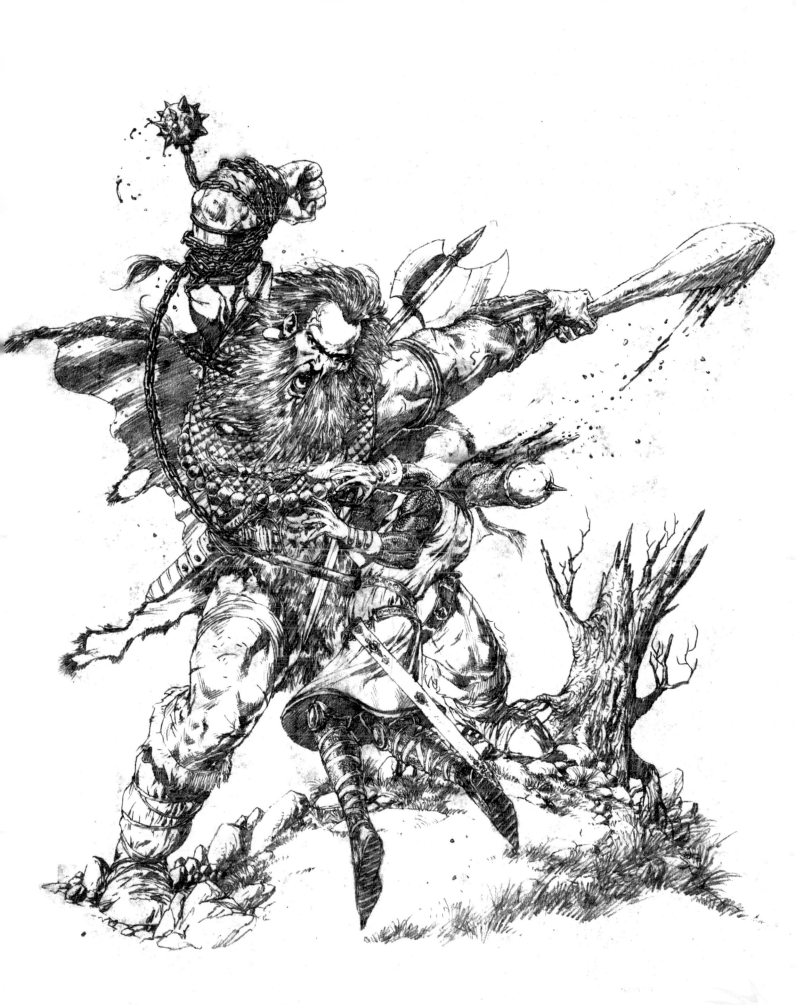

TROLL

Trolls—from the medieval fantasy genre—are my favorites, and a favorite among most fantasy fans, too. They're weird, spooky, and strange, so what's not to like? The troll is truly a nonhuman species. Its head and body have subtle but specific traits that have been carried over from legions of fantasy artists to become an established look. That's not saying that you can't invent your own. Sure you can. However, this example is the "classic troll" and is immediately recognizable to audiences and readers. So it's good to be familiar with it, if only to use it as a springboard for your own interpretations.

The head is shrunken, and the maxilla (upper mouth bone) is elongated. The teeth are bucktoothed, and the ears are huge. The limbs are lanky, but in a specific way: The forearms are longer than the upper arms, and the calves are longer than the thighs—just the reverse of a normal person.

Trolls may be smaller than the giant or the ogre, but they are very powerful for their size, which is perhaps three-quarters of the height of a man. Despite the smaller stature, they are much stronger than humans. And they're famous for being extremely territorial—and for knowing how to use a club. They are not to be reasoned with, but the greedy little buggers can be bribed!

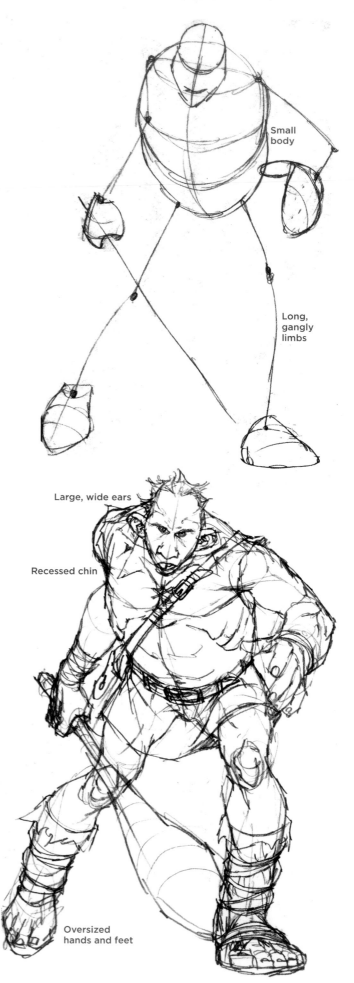

Small body

Long, gangly limbs

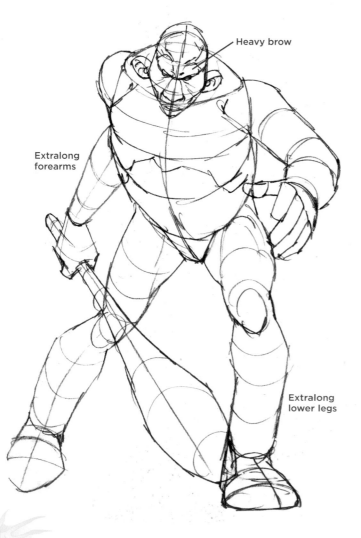

Heavy brow

Extralong forearms

Extralong lower legs

Large, wide ears

Recessed chin

Oversized hands and feet

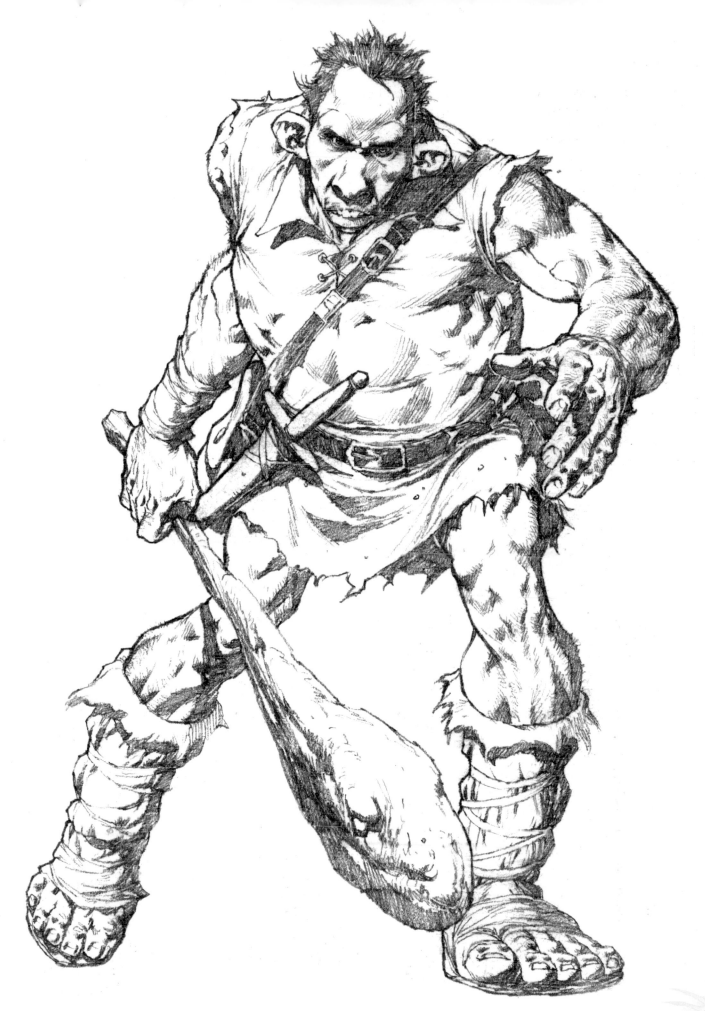

SERPENT LADY

The serpent lady belongs to the medieval world and is often found living among the remains of a long-since abandoned temple, in a city of ruins. It may be that she's guarding the place where the Holy Grail is kept or a treasure that she has been safekeeping for a century.

She must be drawn in a serpentine manner—in other words, winding back and forth and slithering dangerously. No straight lines for the body of a snake! And, there's often a rattle at the end of that tail of hers.

The serpent lady is similar to the Medusa (see page 133), except that the serpent lady is more attractive and can be looked at without the observer turning into stone. But both are predator-killers, and knights must be extremely wary of the serpent if they are to survive an encounter with her. She is a poisonous figure, at once beautiful and horrifying. You can create exciting scenes by having the knight use stealth and cunning to divert the serpent's attention away from her treasure while he makes a play for the Grail. Often, the most dramatic way to destroy a powerful character like this is to find a small vulnerability—for example, that rattle, which can be cut off the tail.

Centerline

Note tilt of hips

Positioning guideline

Handle points toward sky

TIP First sketch a guideline to map out the path of the body. This guideline becomes the centerline and spine of the upper body of the human half of the form.

Centerline on back as well as on underbelly

Striations across underbelly

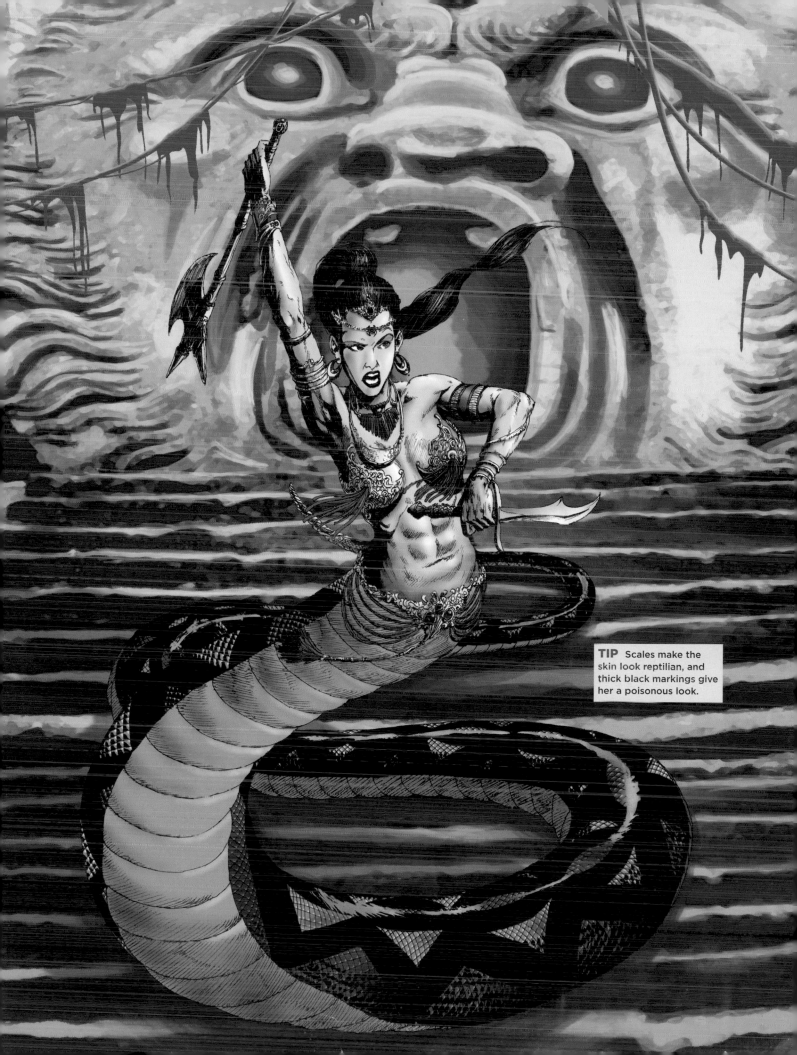

TIP Scales make the skin look reptilian, and thick black markings give her a poisonous look.

OGRE

The ogre, unlike the troll, is a very large being: not a giant, but much bigger than the average man. He has a low forehead and a very thick brow, which gives the impression—accurately—that he's a dim-witted thug. Everything about him is thick, slow, and very, very powerful. From his posture to his proportions, his entire body language spells trouble for those who cross his path. He appears in the medieval fantasy genre.

Back is hunched

Head is small, with neck buried deep into body

Excessively long arms

Excessively short legs

Fists out in front

Misshapen, small chest

Massive, muscular belly

Unlike any other genre of illustration, fantasy art boasts many eerie and fascinating characters who are both fast *and* gigantic—a very dangerous combination typified in this example of the ogre. If he were a giant brute with only lean muscles, he'd look like a comic-book bad guy. If he were sluggish and had only a giant potbelly, he'd look like your uncle Phil. A combo does the trick. (Note that the animal-skin loincloth enhances his savage appearance.)

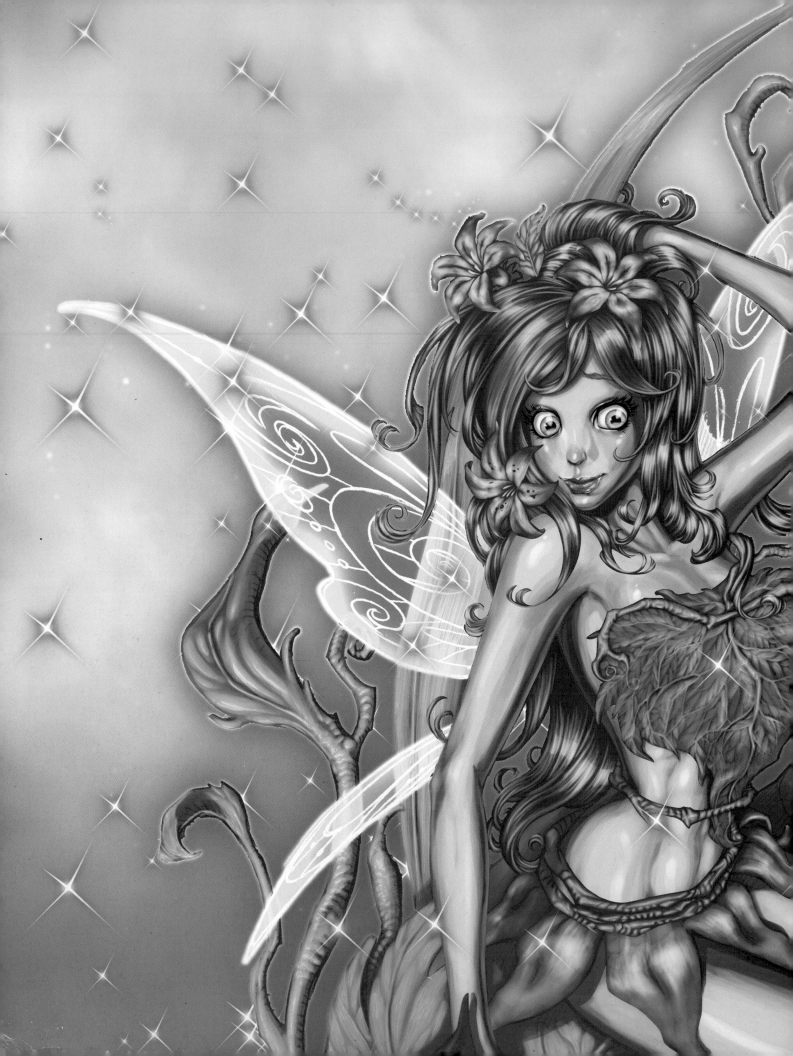

The Enchanted Faerie Realm

FAERIES ARE A SUBSET OF THE fantasy genre, and they enjoy a passionate and devoted following of fans who love the realm of the world's smallest kingdom. Faeries are delightful creatures, blissful by nature, who live in harmony but are never far from danger. They are spiritual, in a quasi-pagan, earthy way. Air, trees, flowers, leaves, running brooks, and clouds are the substance of their lives.

FAERIE FEATVRES

To draw faeries, you must infuse them with a spirit of joy and boundless energy, because faeries are mercurial creatures. Draw them as delicate, elegant, androgynous, wistful, mischievous, and, most of all, playful. Keep in mind, though, that they are varied: There are sinister faeries, too!

Faeries have distinct features and proportions that give them an alluring, charming appearance, which makes them irresistible to humans. Their build is always wispy, making them elusive and all but impossible to catch. Luckily, a few of them have cooperated in posing for this book and having their likenesses drawn, because they happen to have a particular fondness for cartoonists and fantasy artists. They told me that they most certainly would not have done this for lawyers or hedge-fund managers.

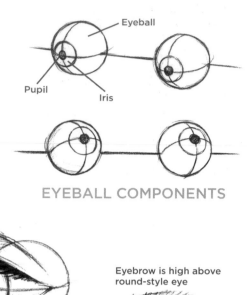

Eyeball
Pupil
Iris

EYEBALL COMPONENTS

EYES

Faerie eyes are generally drawn two different ways: either as a severe almond shape or as super-wide-eyed and round. The round-eyed version is a perkier look. The almond-eyed look is more wistful and can be adapted to an evil character more easily

Eyebrow is high above round-style eye

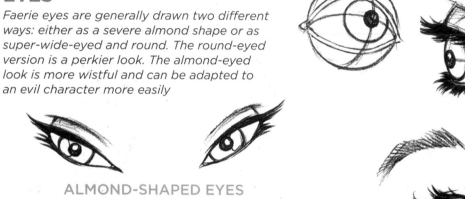

ALMOND-SHAPED EYES

Eyelashes bunch together

Shine makes eye sparkle

EYE SHINES

EYEBROWS AND LASHES

MALE FAERIE EYES

The eyebrows are drawn nearer the eyes. Make sure the pupils align on the same level, and note that even male faeries should exhibit a few eyelashes.

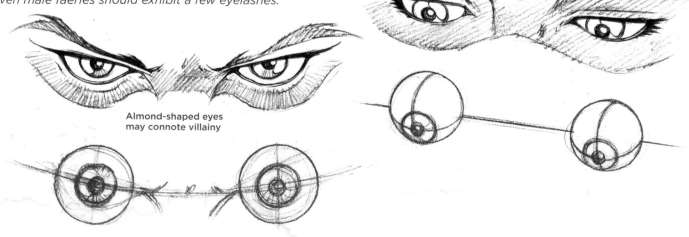

Almond-shaped eyes may connote villainy

102

PROPORTIONS

Human proportions require the top of the ear to align with the eyebrow and the bottom of the ear to align with the bottom of the nose. On faeries, you can extend the top of the ear far past that point, but the bottom of the ear is almost always kept at the same place. Almost!

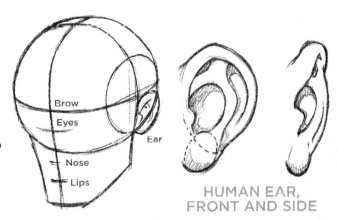

HUMAN EAR, FRONT AND SIDE

EARS AND NOSES

Everyone can recognize a faerie instantly by the pointy ears and nose—these are the hallmark of the little creatures. You can lengthen these features and bend them and curve them to create an individual look for each of your faerie characters so that they don't all look alike. We'll use the human ear and nose as our starting points and springboard off them, using exaggeration to create faerie features.

FAERIE EARS

Note that the earlobe, too, can be drawn in different shapes.

DEVILISH

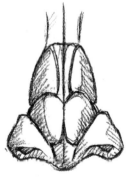

NAUTILUS TYPE

ATTENUATED

SOFTENED

HUMAN NOSE DIAGRAM

FAERIES NOSE DIAGRAM

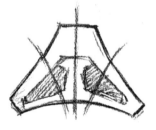

FAERIE NOSES

CLASSIC

DOWNTURNED

FEMALE

CURMUDGEONLY

THE FEMALE FAERIE FACE

FRONT

This is an earthy faerie, as opposed to a faerie princess or faerie warrior. Her hair is carefree and blown about. And she wears an upside-down flower for a hat! The slenderized look of her chin also enhances her charmed, supernatural look.

Jaw is slender

Ears angle away from head

Eyes set low on head for youthful appearance

Shadow is cast on neck just below chin

Flower stem

Upside-down-flower hat

Decorative facial marking highlights character's enchanted nature

TIP The nose is pointed, but in the front view, it's best to draw it as an upturned triangle to show the point at the tip of the nose.

PROFILE

In profile, the faerie's face is like a human's, only more exaggerated with every curve. So don't be afraid to emphasize the deep, sweeping arcs, as you'll see in these steps.

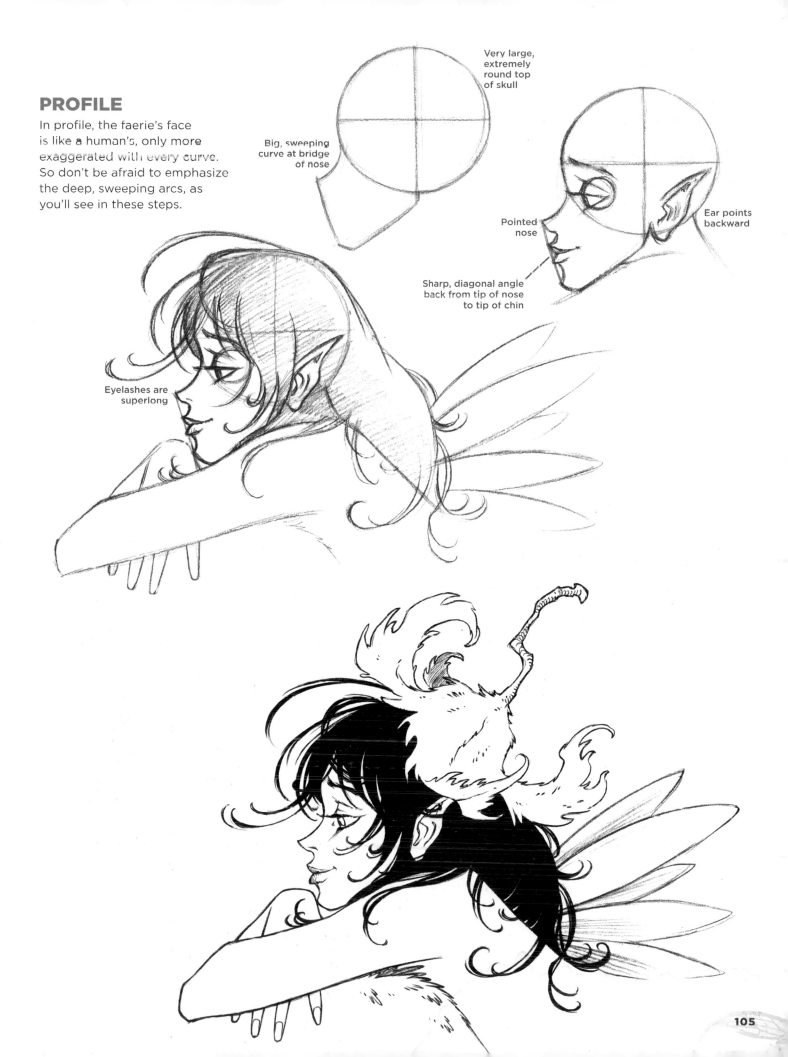

Very large, extremely round top of skull

Big, sweeping curve at bridge of nose

Pointed nose

Ear points backward

Sharp, diagonal angle back from tip of nose to tip of chin

Eyelashes are superlong

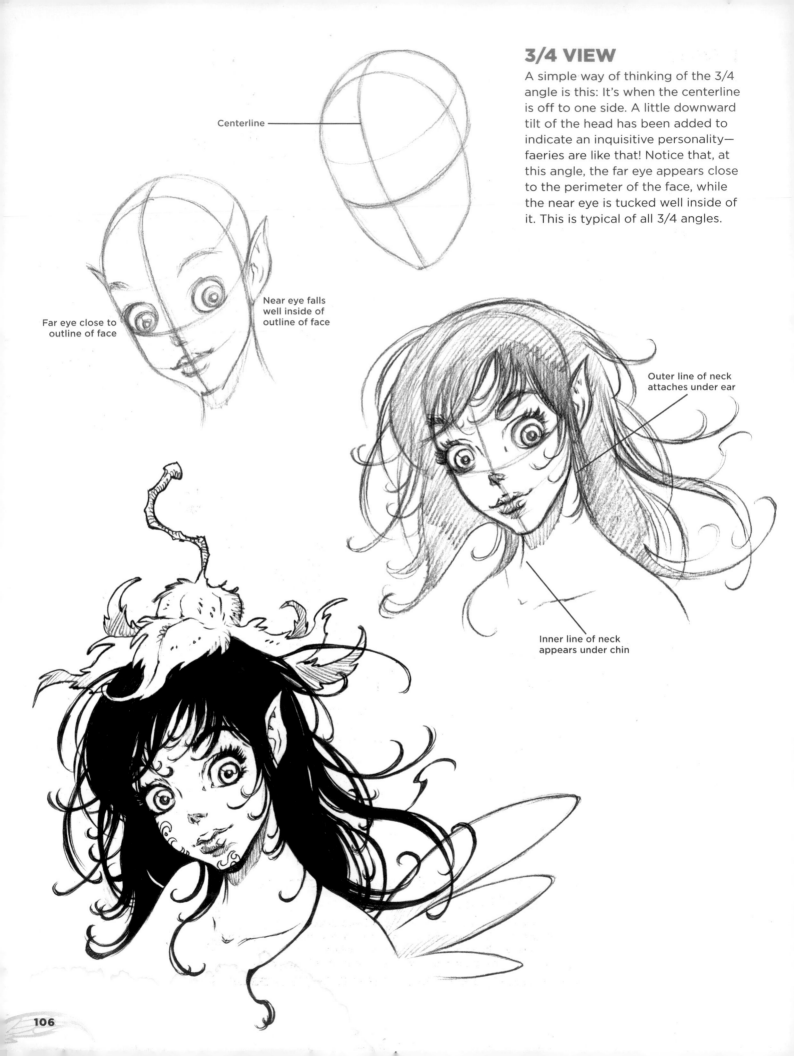

Centerline

3/4 VIEW

A simple way of thinking of the 3/4 angle is this: It's when the centerline is off to one side. A little downward tilt of the head has been added to indicate an inquisitive personality—faeries are like that! Notice that, at this angle, the far eye appears close to the perimeter of the face, while the near eye is tucked well inside of it. This is typical of all 3/4 angles.

Far eye close to outline of face

Near eye falls well inside of outline of face

Outer line of neck attaches under ear

Inner line of neck appears under chin

UP SHOT

"Up" shots are often used to portray hopeful and innocent expressions of emotion.

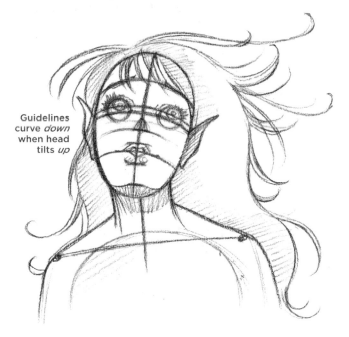

Guidelines curve *down* when head tilts *up*

DOWN SHOT

"Down" shots are often used to convey moments of grief or somber contemplation.

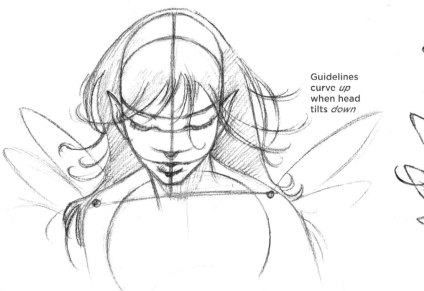

Guidelines curve *up* when head tilts *down*

GUIDELINE HINT

When you draw a character with her head tilted back (looking up), the sketch-in guidelines across the face should curve down. Conversely, when you draw a character whose head is tilted downward, the guidelines across the head should curve up.

THE MALE FAERIE FACE

FRONT

The male faerie is somewhat of an odd-looking fellow. He's elflike—a devil and a troubadour, all wrapped into one. There's a hint of the medieval in his appearance. Notice the hat: It's reminiscent of the conquistadors (although theirs were made of metal). Eye masks such as these were in favor during extravagant costume parties during the Middle Ages.

Top of skull starts as a circle but narrows sleekly at the sides

Delicate chin

Eyebrows placed close to eyes and flared at ends

Elegant, almond-shaped eyes

Top and bottom of ears come to a point

Nose has extra length

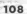

PROFILE

In the side view, the front plane of the male faerie's face is flat, straight up and down; it doesn't angle inward at the chin like the female faerie. The bridge of the nose is greatly exaggerated. The eyebrow is drawn along a high arch, creating a devilish look. But all of the features are rather delicate.

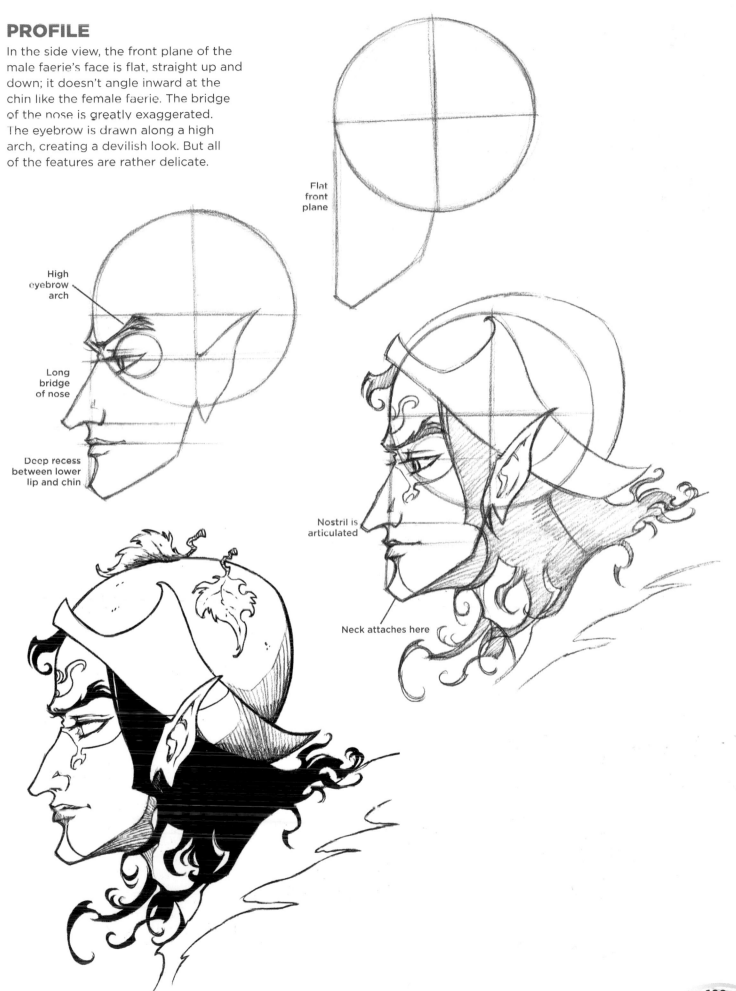

Flat front plane

High eyebrow arch

Long bridge of nose

Deep recess between lower lip and chin

Nostril is articulated

Neck attaches here

FAERIE BODY PROPORTIONS

FEMALE FRONT

The faerie is 7 heads tall—or taller, if you wish. Imagine that—a lanky faerie! It's ironic, considering that they're thimble-sized beings. The head-to-hip portion of the body should be visibly shorter than the hip-to-leg portion. The extralong legs give your faerie a lithe appearance. So, when you're drawing your faerie body, be it male or female, shrink the torso just a bit and lengthen the legs just a touch, and you'll get the right effect.

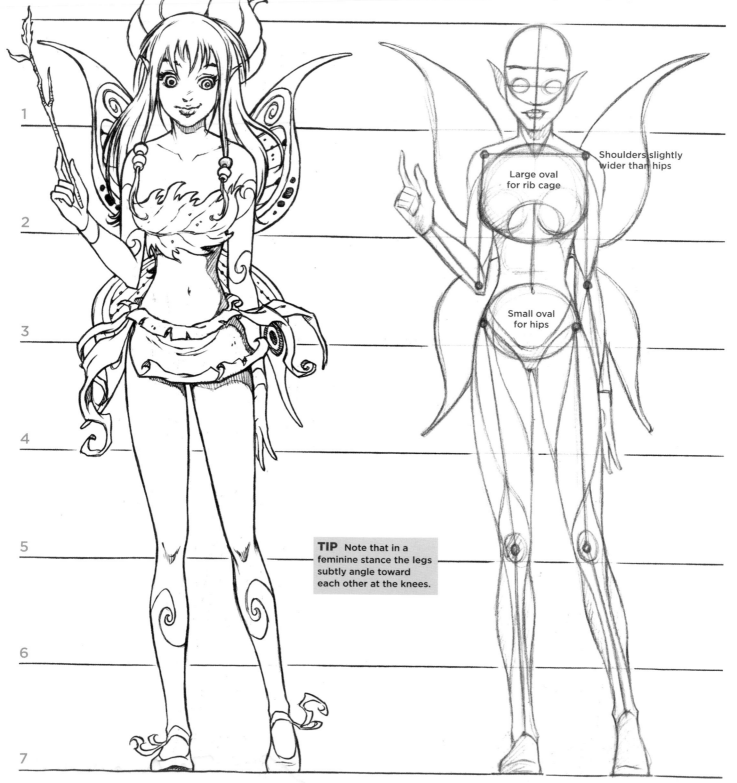

Shoulders slightly wider than hips

Large oval for rib cage

Small oval for hips

TIP Note that in a feminine stance the legs subtly angle toward each other at the knees.

FEMALE 3/4 VIEW

Just as in the 3/4 view of the face, in the 3/4 view of the body, the centerline is off to the side. Also, in the 3/4 view the near side of the body will overlap areas of the far side of the body, such as the far leg and arm.

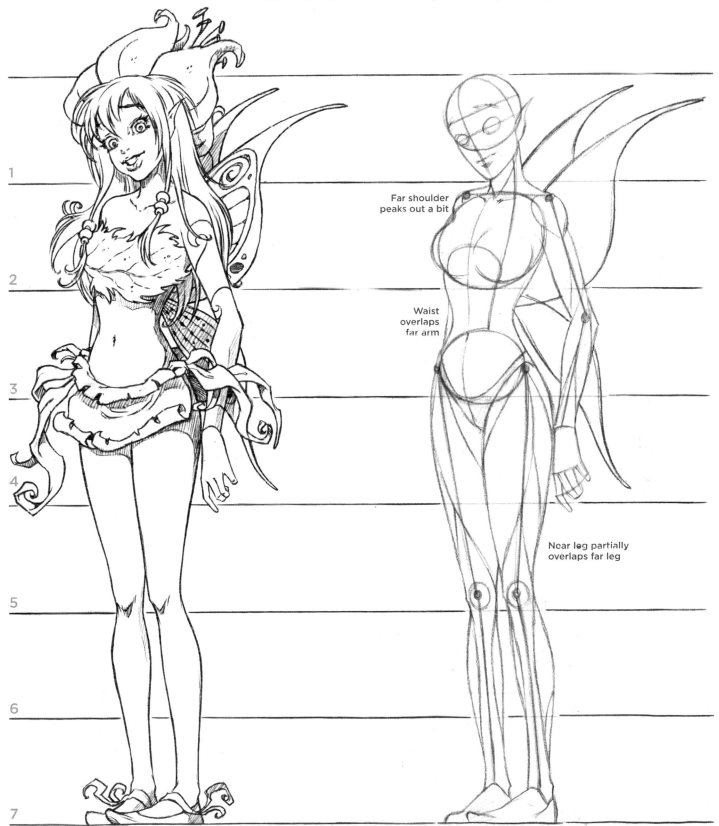

Far shoulder peaks out a bit

Waist overlaps far arm

Near leg partially overlaps far leg

MALE FRONT

Although his shoulders are wide, he does not—and should not—give the impression of being physically powerful. He's a winged being who must be able to be carried by the wind. Agility and speed, not strength, are his forte. Therefore, keep him long and lanky, with swimmer's—not weight lifter's—muscles.

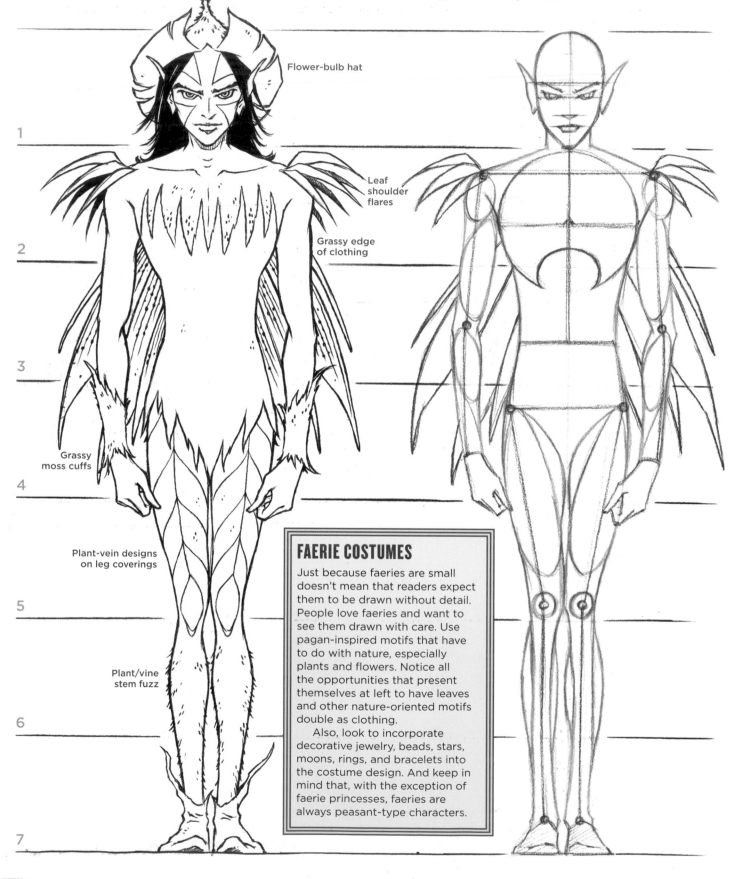

Flower-bulb hat

Leaf shoulder flares

Grassy edge of clothing

Grassy moss cuffs

Plant-vein designs on leg coverings

Plant/vine stem fuzz

FAERIE COSTUMES

Just because faeries are small doesn't mean that readers expect them to be drawn without detail. People love faeries and want to see them drawn with care. Use pagan-inspired motifs that have to do with nature, especially plants and flowers. Notice all the opportunities that present themselves at left to have leaves and other nature-oriented motifs double as clothing.

Also, look to incorporate decorative jewelry, beads, stars, moons, rings, and bracelets into the costume design. And keep in mind that, with the exception of faerie princesses, faeries are always peasant-type characters.

MALE SIDE

We'll get to wings in depth on pages 114–115, but just note here that the wings of the male faerie are generally not drawn as ornately as those of the female faerie. On a female faerie, the wings heighten her femininity; on male faeries, they're more utilitarian. They indicate to us that he can fly, and that's quite sufficient. Here, you see them in the retracted position.

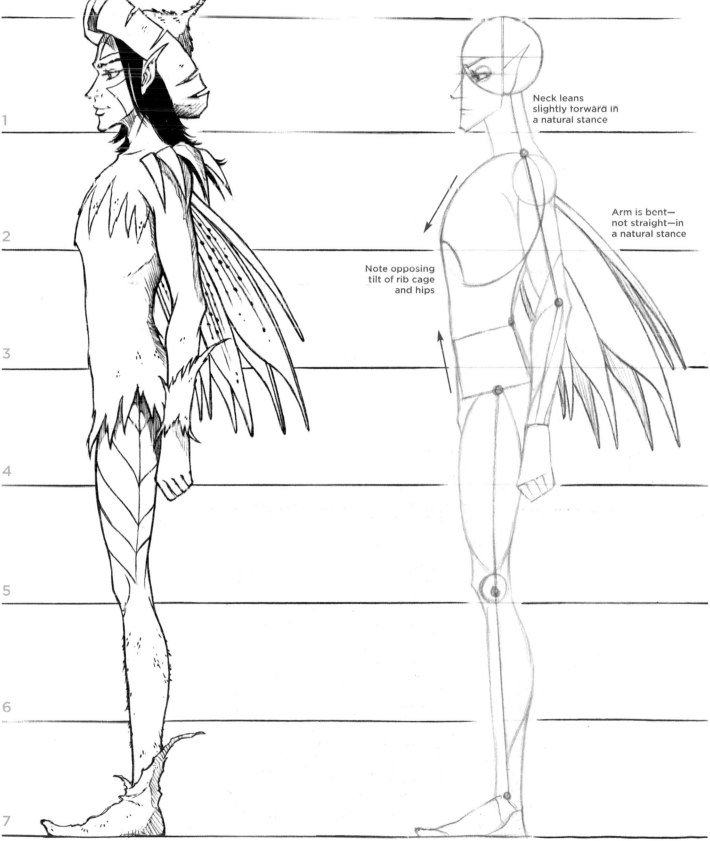

Neck leans slightly forward in a natural stance

Arm is bent—not straight—in a natural stance

Note opposing tilt of rib cage and hips

FABULOUS FAERIE WINGS

As mentioned on page 113, when you think of elaborate faerie wings, you're talking about *female faerie* wings. The most common styles are the butterfly, dragonfly, and spine types. Those account for the basic wing shapes. The most popular are the butterfly wings, which are the largest. They look like massive sails and capture the wind—and the mood! And they're often beautifully decorated. Dragonfly wings are the next most popular. They're narrow and long and come in pairs, so each dragonfly-type faerie sports four wings or more. The spine varieties are the least common. They show the skeletal structure within the wing itself, like the wings of a bat or prehistoric bird. Spine-style wings can be beautiful, as well, but you must take care to draw them elegantly or you run the risk of having them look like they're from a horror genre.

DRAGONFLY

BUTTERFLY

DRAGONFLY

SPINE

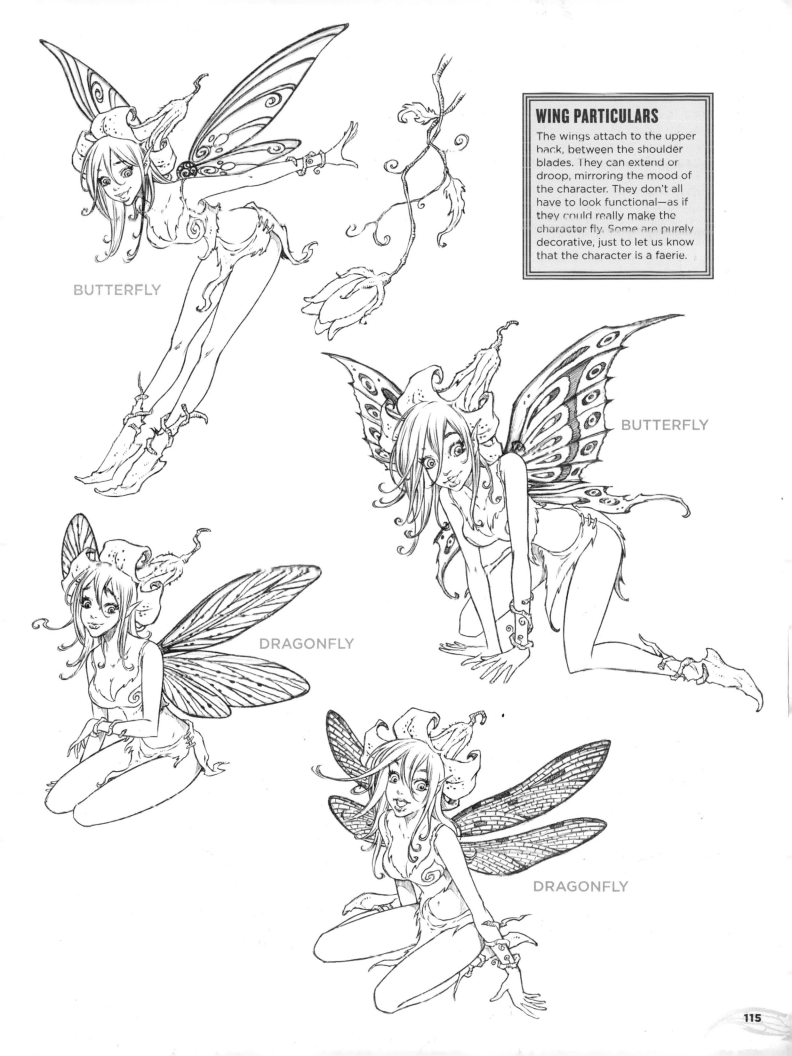

BUTTERFLY

BUTTERFLY

DRAGONFLY

DRAGONFLY

WING PARTICULARS

The wings attach to the upper back, between the shoulder blades. They can extend or droop, mirroring the mood of the character. They don't all have to look functional—as if they could really make the character fly. Some are purely decorative, just to let us know that the character is a faerie.

SEASONAL FAERIES

Faeries and nature go together. In fact, some people believe that faeries cause the forces of nature to occur. I won't say whether that's true or not except to state that there's a lot of evidence pointing in that direction.

One thing that we do know is that the four seasons are ushered in by four very different types of faeries. A few very observant humans have spotted these seasonal faeries in various meadows, mostly in the hills of Scandinavian countries, from which they make their arduous journeys around the globe. These illustrations come from firsthand, eyewitness accounts.

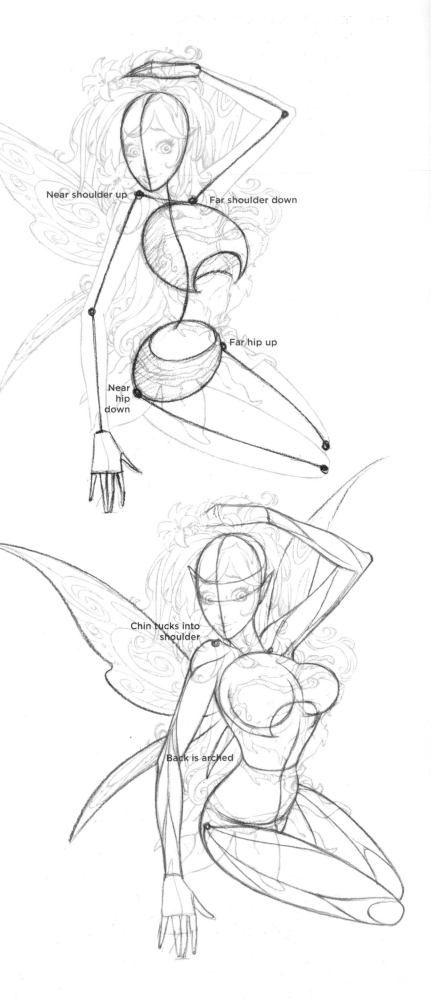

Near shoulder up

Far shoulder down

Far hip up

Near hip down

Chin tucks into shoulder

Back is arched

SPRING FAERIE

This one awakens in April, shaking off the effects of a long winter's slumber, just as the flower petals start to rustle. Spring brings to mind the emergence of the growth of foliage. Therefore, as artists, we use that concept in defining character. Costume her in earth tones, completely dressed from head to toe in assorted leaves and petals.

SPRINGTIME POSE: SITTING ON AN OPENED FLOWER

In this pose, her legs are tucked beneath her, effectively eliminating the lower legs from the drawing. Her lower back is arched, giving her posture a positive emotion.

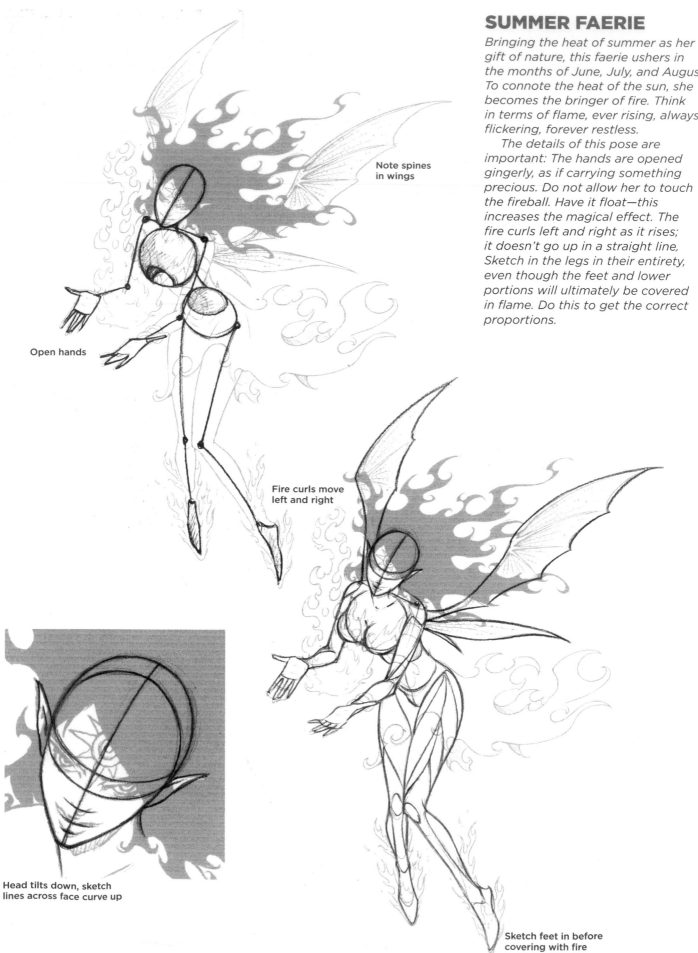

SUMMER FAERIE

Bringing the heat of summer as her gift of nature, this faerie ushers in the months of June, July, and August. To connote the heat of the sun, she becomes the bringer of fire. Think in terms of flame, ever rising, always flickering, forever restless.

The details of this pose are important: The hands are opened gingerly, as if carrying something precious. Do not allow her to touch the fireball. Have it float—this increases the magical effect. The fire curls left and right as it rises; it doesn't go up in a straight line, Sketch in the legs in their entirety, even though the feet and lower portions will ultimately be covered in flame. Do this to get the correct proportions.

Note spines in wings

Open hands

Fire curls move left and right

Head tilts down, sketch lines across face curve up

Sketch feet in before covering with fire

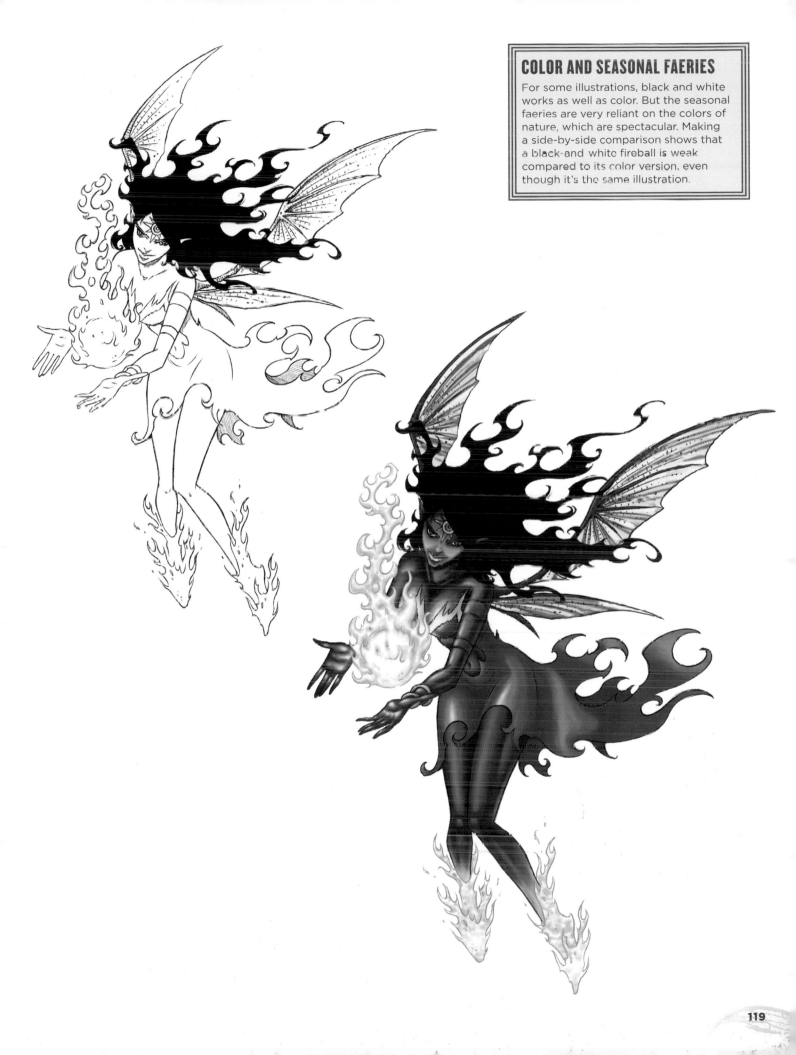

COLOR AND SEASONAL FAERIES

For some illustrations, black and white works as well as color. But the seasonal faeries are very reliant on the colors of nature, which are spectacular. Making a side-by-side comparison shows that a black-and white fireball is weak compared to its color version, even though it's the same illustration.

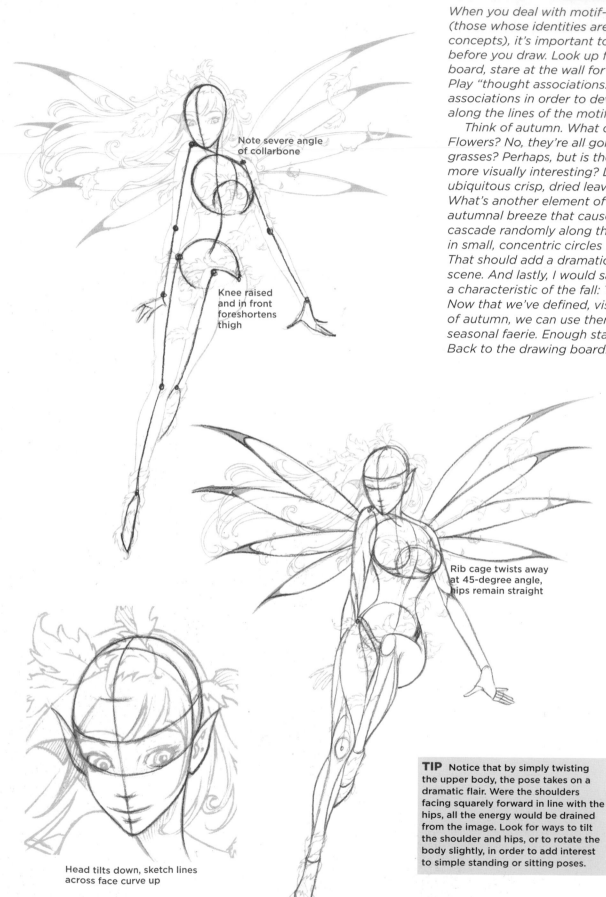

AUTUMN FAERIE

When you deal with motif-based characters (those whose identities are based on concepts), it's important to pause a moment before you draw. Look up from the drawing board, stare at the wall for a minute, and think. Play "thought associations." You'll need these associations in order to develop the character along the lines of the motif.

Think of autumn. What comes to mind? Flowers? No, they're all gone by then. Dried grasses? Perhaps, but is there something more visually interesting? Leaves? Yes, the ubiquitous crisp, dried leaves. Let's go further. What's another element of fall? Wind. The autumnal breeze that causes the leaves to cascade randomly along the ground and swirl in small, concentric circles in the air. Great. That should add a dramatic touch to the scene. And lastly, I would say that scarcity is a characteristic of the fall: The trees are bare. Now that we've defined, visually, the elements of autumn, we can use them to define our seasonal faerie. Enough staring at that wall! Back to the drawing board!

Note severe angle of collarbone

Knee raised and in front foreshortens thigh

Rib cage twists away at 45-degree angle, hips remain straight

Head tilts down, sketch lines across face curve up

TIP Notice that by simply twisting the upper body, the pose takes on a dramatic flair. Were the shoulders facing squarely forward in line with the hips, all the energy would be drained from the image. Look for ways to tilt the shoulder and hips, or to rotate the body slightly, in order to add interest to simple standing or sitting poses.

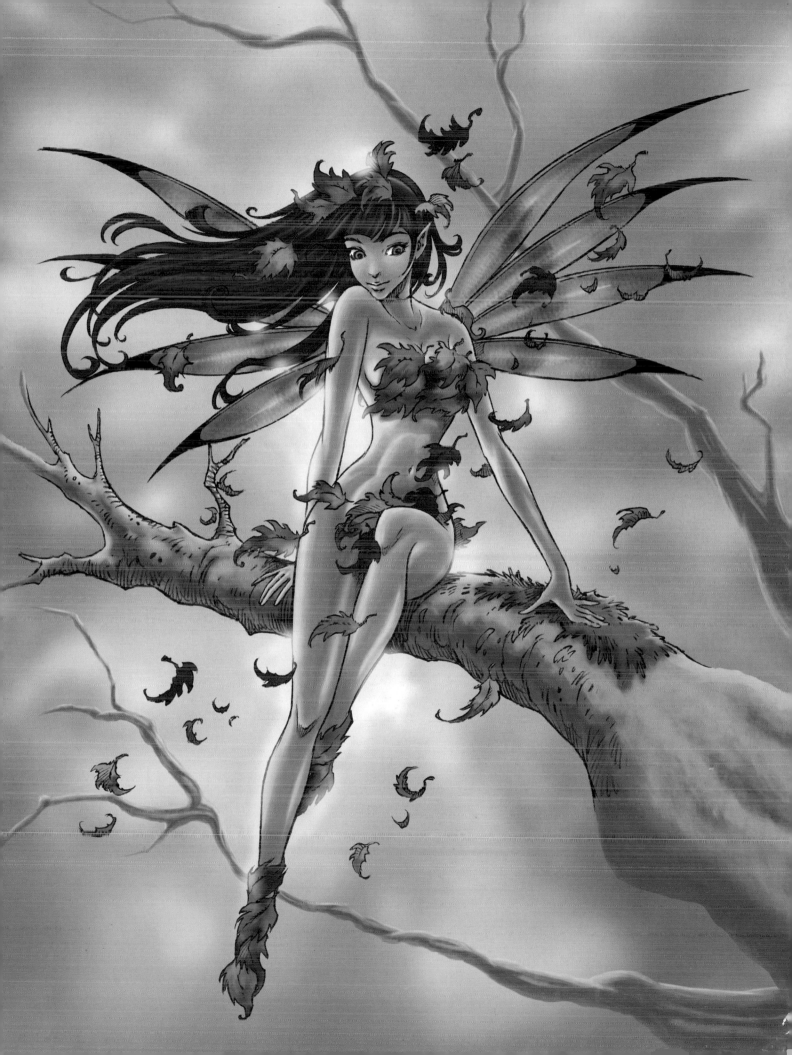

WINTER FAERIE

As the snow faerie descends upon the woodlands, all of nature's creatures become sleepy and ready their homes and nests for a long winter's nap. The classic pose shows the winter faerie surveying the landscape and bringing a gentle blanket of snow to the land. Her outstretched wings catch the breeze like a kite and keep her aloft. The wings are slightly ruffled, reminiscent of bird wings, and colored primarily white, like snow. She is bundled up to reflect the temperature of the season, wearing a quasi-princesslike winter costume with fur-trimmed jacket. The hat is large and reminiscent of a crown.

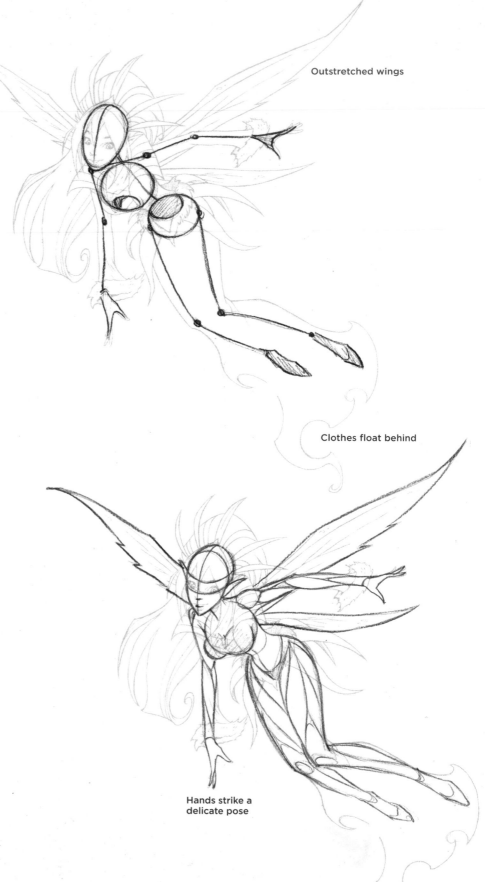

Outstretched wings

Clothes float behind

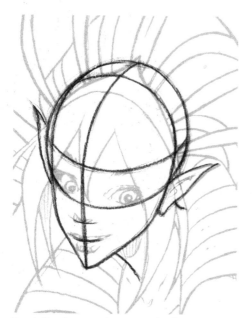

Head tilts downward to survey landscape

Hands strike a delicate pose

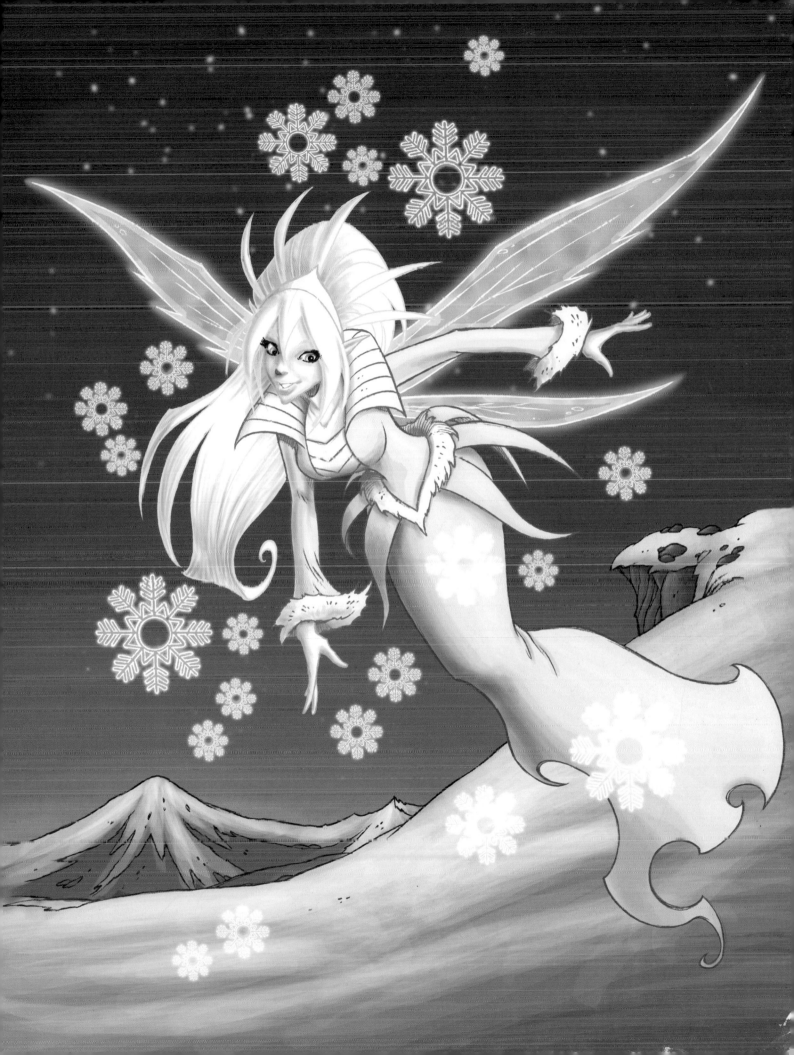

FAERIE DETAILS

Just because faeries are small doesn't mean that your audience expects them to be drawn without details. People love faeries and want to see them drawn with care. Use pagan motifs having to do with nature—mainly plants and flowers. Look to incorporate decorative jewelry (like rings and bracelets), beads, stars, and moons into the costume design.

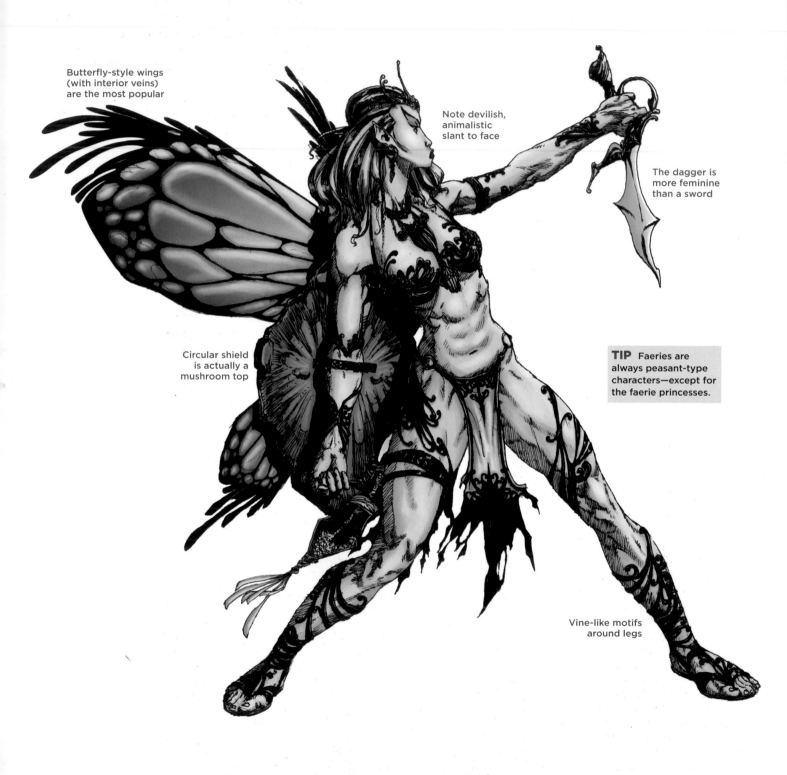

Butterfly-style wings (with interior veins) are the most popular

Note devilish, animalistic slant to face

The dagger is more feminine than a sword

Circular shield is actually a mushroom top

TIP Faeries are always peasant-type characters—except for the faerie princesses.

Vine-like motifs around legs

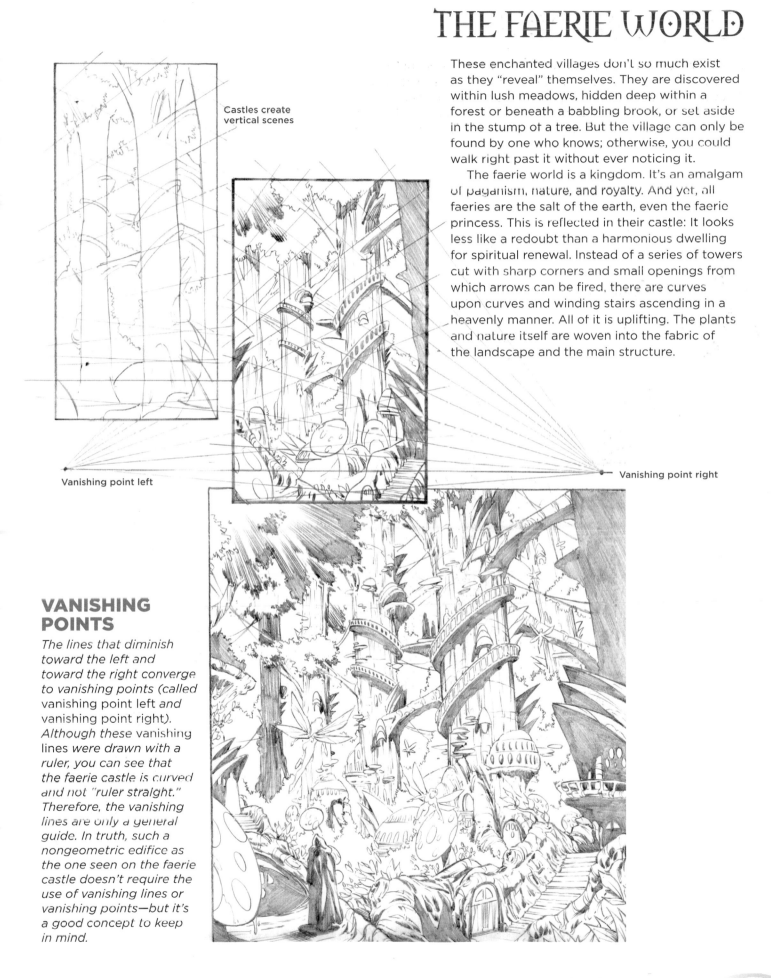

THE FAERIE WORLD

Castles create vertical scenes

Vanishing point left

Vanishing point right

These enchanted villages don't so much exist as they "reveal" themselves. They are discovered within lush meadows, hidden deep within a forest or beneath a babbling brook, or set aside in the stump of a tree. But the village can only be found by one who knows; otherwise, you could walk right past it without ever noticing it.

The faerie world is a kingdom. It's an amalgam of paganism, nature, and royalty. And yet, all faeries are the salt of the earth, even the faeric princess. This is reflected in their castle: It looks less like a redoubt than a harmonious dwelling for spiritual renewal. Instead of a series of towers cut with sharp corners and small openings from which arrows can be fired, there are curves upon curves and winding stairs ascending in a heavenly manner. All of it is uplifting. The plants and nature itself are woven into the fabric of the landscape and the main structure.

VANISHING POINTS

The lines that diminish toward the left and toward the right converge to vanishing points (called vanishing point left *and* vanishing point right). *Although these* vanishing lines *were drawn with a ruler, you can see that the faerie castle is curved and not "ruler straight." Therefore, the vanishing lines are only a general guide. In truth, such a nongeometric edifice as the one seen on the faerie castle doesn't require the use of vanishing lines or vanishing points—but it's a good concept to keep in mind.*

DARKNESS FALLS: THE GOTHIC CHARACTERS

LEST YOU THINK THAT THE FANTASY REALM IS ALL about knights, trolls, and ogres, get ready to roll up your sleeves again! We're about to embark on the darkest part of our journey to the far corners of the seven seas. It is there that we'll find the creatures and characters who inhabit the Lost Worlds—from which no man returns. Here lie the beings who guard the gates of Hell. They are otherworldly, intensely evil, and compelling to behold. In fact, they make up some of the most popular and enduring movie and comic book characters of all time. They are as likely to look like elegant people as they are to look like monsters. But never trust appearances in the Gothic world of fantasy—never.

DEAD PIRATES

Bad pirates never die; they haunt the sea in ghost ships forever! Although they have all the accoutrements of living pirates—the classic tricorn pirate hat, flintlock pistol, swashbuckler's cutlass, and knee-high boots—they're all skeleton. Even though they're all bones, classic pirates-from-beyond have a strong and stout figure with a broad frame. The head is an eerie combination of a bony skull with beady eyes and a long, ever-growing, wild beard. A variation is to leave the eye sockets hollow. It makes for more of a possessed look.

DRAMATIC LIGHTING EFFECTS

The fantasy world is nothing if not dramatic—heavily dramatic, to be precise. Once you've got your image the way you want it, you can still ratchet up the heroism by adding a burst of high-contrast shadow. This isn't soft shading, but rather a stark blanketing of black and white. Yes, it will eliminate some of your hard-won linework, but it won't be lost on the readers. Their eyes will automatically fill in the lines lost in shadows if you've drawn the figure well.

Be generous with your shadows. Lose the figure in their blackness. Conversely, lose some details baking in the well-lit areas as well, such as the face. Note the direction of the light source, which dictates the patterns of the shadows. Even if the source of the light isn't seen in the picture (and even if you haven't decided exactly what the light source is), you still have to decide from what angle it's coming in order to have some cohesive thoughts about where to place the shadows that result from it. The light source hits not only the figure but also anything behind and underneath it. This gives the character a feeling of solidity, weight, and reality.

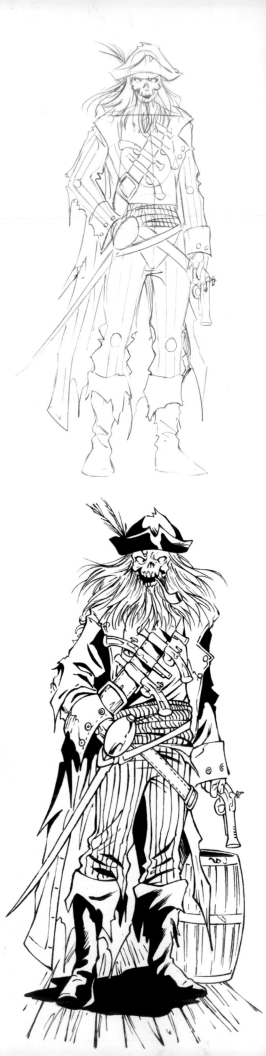

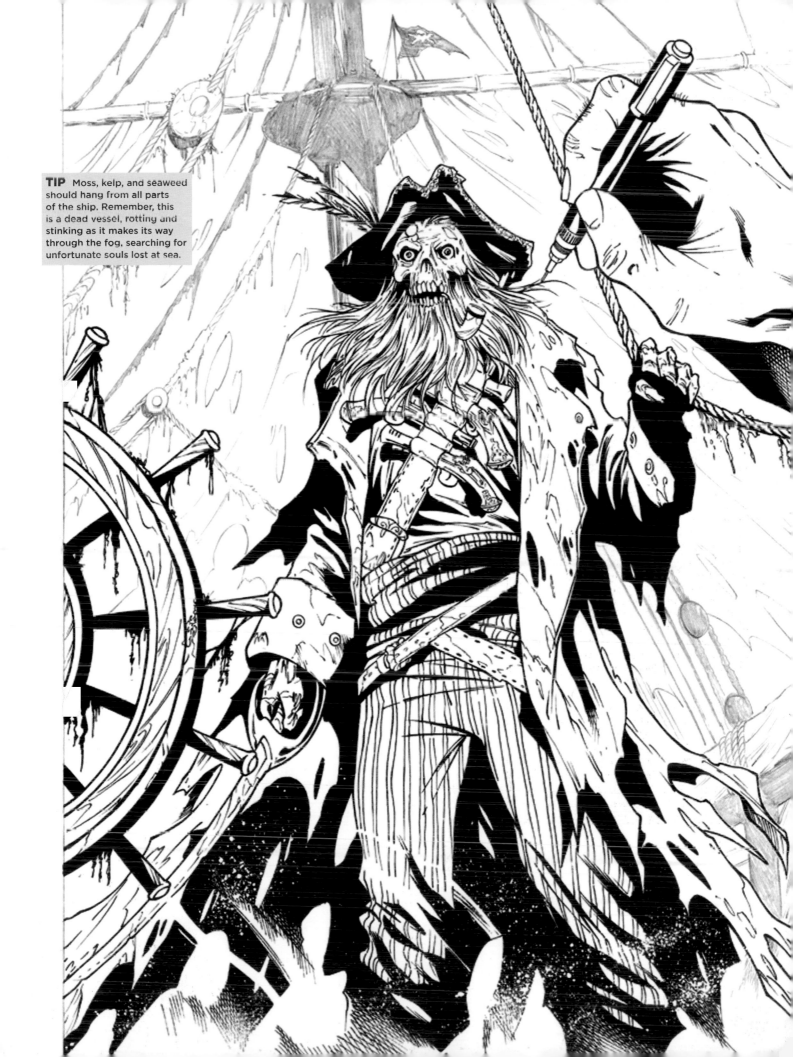

TIP Moss, kelp, and seaweed should hang from all parts of the ship. Remember, this is a dead vessel, rotting and stinking as it makes its way through the fog, searching for unfortunate souls lost at sea.

CLASSIC VAMPIRE

The classic vampire has a European flair to him. He wears a cape and aristocratic clothing, brushes his hair back, and perhaps even has a goatee. Like a werewolf, a vampire can have a transformation (see page 138)—usually, when he decides to attack. But his transformation isn't so startling because he's already somewhat unearthly in appearance. His fangs extend, his eyes grow empty and severe, his ears become attenuated, his fingernails turn into claws, and his feet become anatomically feral. And, his is not a painful transformation; rather, it's a "reverse" transformation: He's becoming who he really is. His human form was the deception.

Layered clothing of the upper classes

Claws emerge

Tattered cape

Feet become animalistic

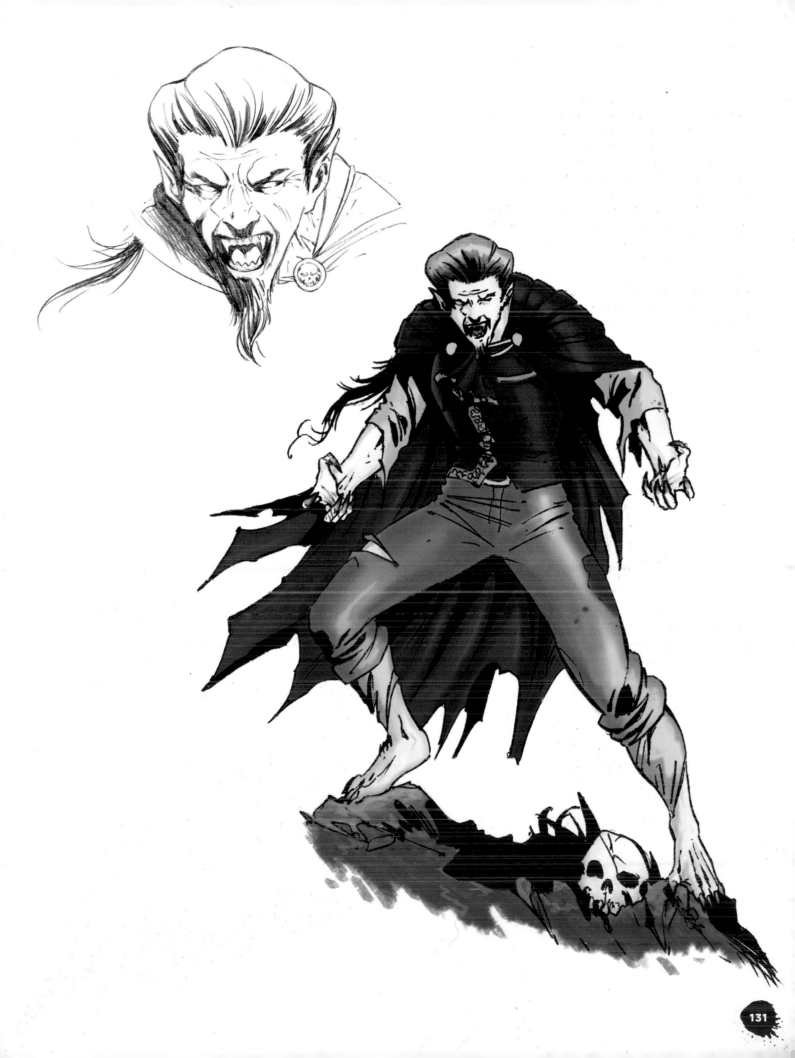

LADY VAMPIRE

This one is the queen of darkness, royalty of the underworld. She's a dark temptress—dangerous, cunning, and in need of mortal blood to replenish her youth. Foreign tourists lost in the countryside of eastern Europe may sight a castle on a hill during a torrential rainstorm. They hurry over and inquire of the servant if the owner will allow them to stay the night, to give them shelter. Well, by all means, of course she will!

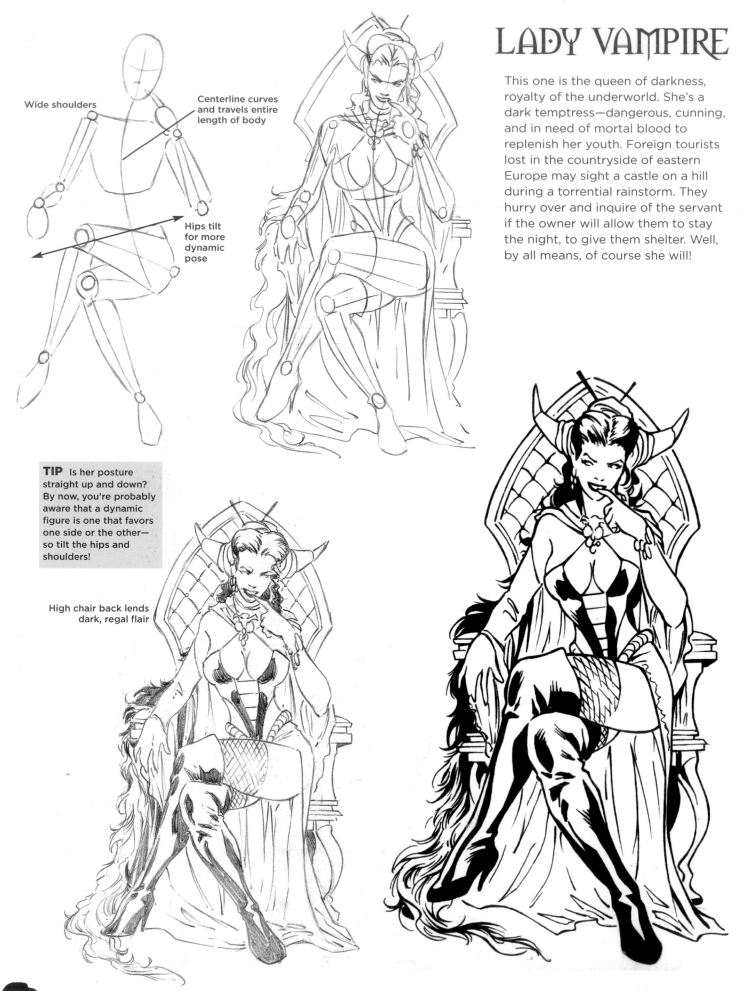

Wide shoulders

Centerline curves and travels entire length of body

Hips tilt for more dynamic pose

TIP Is her posture straight up and down? By now, you're probably aware that a dynamic figure is one that favors one side or the other—so tilt the hips and shoulders!

High chair back lends dark, regal flair

132

MEDVSA

I've been on some bad blind dates in my day, but this gal—whew!— is really challenging. According to legend, one look at the Medusa instantly turns you into stone. But, hey, I hear she's a great dancer.

The Medusa is a monster with origins in Greek mythology . . . and a head full of snakes. The snakes are constantly on the move, snapping and looking to attack. My question is, How could she let herself get that way? Couldn't she at least have borrowed shampoo from, say, another Greek monster with better hair? Since one glance at her turns you into stone, the only way you can look at her and survive is if you observe her reflection in your sword or your shield or, perhaps, in water.

Receding hairline makes for a severe female character

Hair should be a tangle of snakes, not just half a dozen or so

Whoops— he looked!

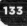

WRAITH

The wraith—a ghostlike apparition—is a cursed, frightening figure, forever flying in and out of this dimension. He seeks solace, but what he has seen in the horrible depths below has driven him mad, and he is condemned to spend the rest of his days flying aimlessly throughout the mists of eternity. He's like someone who has peered behind the counter at the school cafeteria and has actually witnessed how they made the burrito. Shiver!

SHOWING A CHARACTER IN FLIGHT

Draw both knees bent to indicate that the character is flying and, thus, airborne. Another helpful hint is to make sure all of the clothing, as well as the hair, is flapping in the wind.

Hair turns white
as result of
terrible fear

Eyes are giant
and empty

Forever chained
to the past

THE GRIM REAPER

The grim reaper's most famous symbol is his scythe. The symbolism dates back to the Middle Ages. The scythe was a farming tool. During the plague, the grim reaper was thought of as a terrible collector who harvested souls—thus, the scythe. In paintings and images, the grim reaper often had his hapless victims in tow. In fantasy illustration, one has only to be visited by the grim reaper to have received the most unwelcome message of all. Maybe you were wondering if he is, perhaps, benevolent and simply misunderstood? Have no illusions: He's not.

Wings for this Angel of Death

Scythe always has large, curved blade

Captured souls being ferried to netherworld

GARGOYLE

You thought they were only *attached* to buildings. But then, you never took a closer look at the tall buildings at night, when they were *following you with their eyes*. Sometimes, they swoop down on unsuspecting souls and carry them across the river to their nests in the hills, where their young eagerly await them. Young gargoyles are very fond of humans. Especially with a dash of dill.

Gargoyles are classic Goth creatures, demons with bat wings and a tail. You don't need to be in Olde Europe when you have a gargoyle in your story. The scene can even be set in the present, in some metropolis—so long as the city has tall skyscrapers, dark shadows, and Gothic buildings. On the building cornices, these so-called figurines are carved—and waiting for their chance.

Shaggy mane

Oversized ears

Cloven hooves (sign of demons)

THE DIFFERENCE BETWEEN GARGOYLES AND VAMPIRES

Putting aside the difference in legends as to the undead and blood, there are visual differences that make these two icons of the Gothic world distinct entities. The gargoyle is more of a "demon-beast" than the vampire, as its cloven hooves and shaggy mane attest. The gargoyle is a creature of immense power, as opposed to the more elegant and seductive Nosferatu. The gargoyle possesses, typically, very large ears and, often, horns as well.

TRANSFORMATIONS: FROM MAN TO WEREWOLF

There are transformations, and then there are *transformations*. The metamorphosis from man to wolf-beast is, perhaps, the most exciting and powerful, because it is the most excruciating, painful, and frightening to the one afflicted by the curse. Unlike a vampire, the werewolf doesn't *want* to be a werewolf. He dreads the full moon. He tries to escape its power over him. But the spell is eternal, and he finds that he cannot. His soul is damned. This sequential series of panels shows the classic stages a man goes through when the full moon appears in the sky. (Note: The word *lunacy* originally meant a condition of insanity caused by the full moon!)

PANEL SEQUENCE

The man recognizes the full moon. He knows what's coming, and there is little time! He recognizes the changes starting to occur—small first, then growing—and still he tries to find shelter, to hide, to protect others from what he might do . . . but it's no use. It overtakes him. He can no longer escape it. The transformation is in full swing—and it is agonizingly painful! The beast emerges and howls at the moon. It's a sound that can be heard for miles. And it frightens the villagers, who know, in their bones, that murder is in the air tonight.

WHOOOOOOOOO

GOTHIC BIRDS OF PREY

First, only a few appear, and one barbarian female can fend them off. Then clusters start to come, more and more, until they darken the horizon. The aerial assault is a well-oiled standard of the fantasy genre, with the Gothic predator bird its star villain. The ability of the predatory bird to remain aloft and continuously peck at its victim creates a panic of helplessness that heightens fear in the reader. In a scene such as this, we feel that we are peering into the future, for we see that the heroine cannot last long. She will soon be overwhelmed.

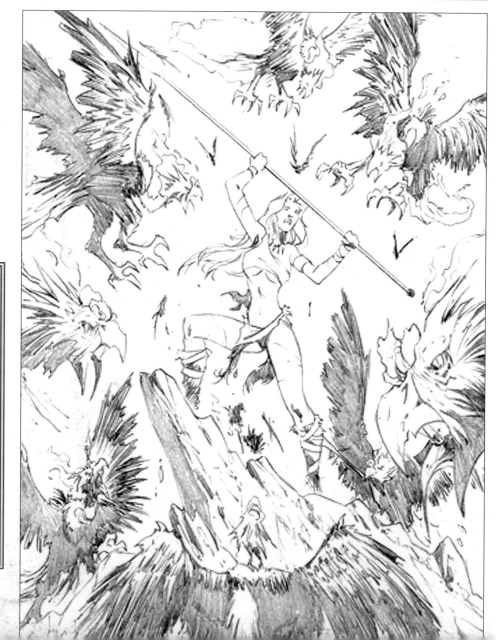

A NOTE ABOUT COMPOSITION

One of the standard rules of layout is that it's boring to place the focus of the scene directly in the middle of the picture. Ahem. See how far mindlessly following the rules will get you? Generally, this is true. However, when there's a point to be made, and you have an effective way to do it, the rules can come second. Except when I give a rule! Just kidding!

The character is placed at the center to emphasize the fact that she's being, literally, circled. Where else would you place her? But in case you still want to please your art teacher, toss in a diagonal—the spear will add some dynamics in that regard.

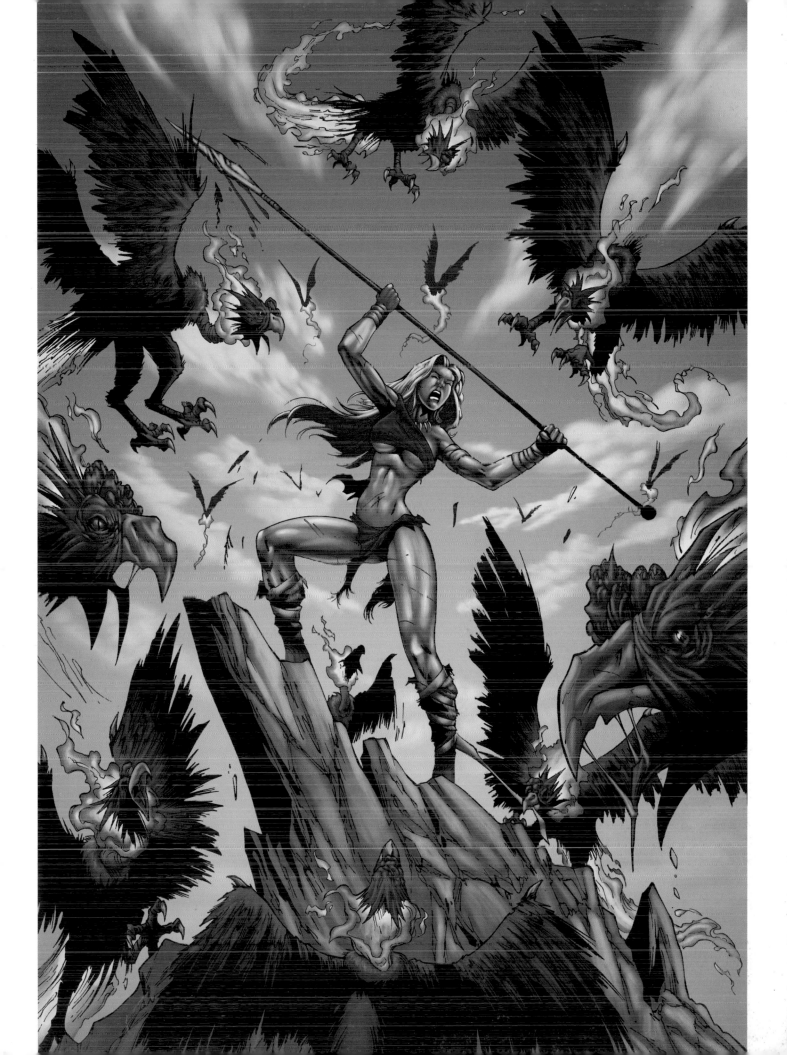

TWO-HEADED DOG

This is one of my favorite characters: the two-headed guardian of Hades. How does the hero get past him to retrieve the girl/treasure/sacred jewel/map? This creature's pricked ears mean that it is ever alert. Chances are slim you'll be able to sneak past while it is sleeping. Instead, you're going to have to slay it. But odds aren't in your favor. This puppy has been around a long, long time . . . and he likes to play.

Extremely important is the strength you show in this animal. You can convey that primarily by building up the withers (shoulder area). You need to do this anyway, because you require room to build the origin for two necks. Also, hang the heads lower than the peak of the shoulders. This hunched posture instantly conveys a predatory, muscular stance.

Heads hang lower than withers

Split shoulders where two necks connect

Spiked collar reflects evil intent

Leave eyes empty (without irises or pupils) for ferocious look

THE GOTHIC WORLD OF DRAGONS

You may be interested in taking one, or several, of your characters and creating an entire scene around them. Perhaps it's a drawing that you want to spend a little extra time and effort on, and you want to make it special. In that case, a background—an environment—would greatly enhance the picture. Staging a scene catapults us into a different world and enables us to suspend disbelief.

As an example, take a look at this scene of dragons gathering together. At the far corners of the earth, near the top of the world, is where the terrible fire-beasts congregate to spawn. High above the villages, the king of predators surveys all that is below. It's always a good practice to begin a story with what is known as an establishing shot. This is simply a wide shot that sets up the background, gives readers their bearings, and anchors them in a time and place. A horizon line and vanishing lines and their corresponding vanishing points have been indicated. These have been included merely as a conceptual aid to assist you in envisioning the scenes in perspective. Note that, whatever your subject, you should strive to build a cohesive "look" in the architecture or environment.

The horizon line (A) is placed either below or above the midpoint of the panel to avoid splitting it evenly in two, which is to be avoided unless there's a strong reason for it. The focal point (B) of the fantasyscape is placed off-center. All the characters look toward the vanishing point, creating an asymmetrical point of interest that the eye is drawn to. You direct the eye of the reader so that some parts of the scene are more important than others, which avoids monotony.

Placing a dragon (C) big in the foreground creates layers, adds a dimension of depth, and conveys the violence or peacefulness of the civilization, which is important information. Alternate fleshed-out characters (D) with some silhouettes (E) for variety and visual pacing.

INDEX